IMAGES
of America

WARRENTON

ON THE COVER: General Sumner and his staff pose in 1862 for a photograph on the steps of Mecca, a grand home in Warrenton used as headquarters by Sumner after it served as a hospital during the First and Second Battles of Bull Run. During Union occupation, a telegraph wire connected Mecca directly to Washington. (Library of Congress.)

IMAGES
of America

WARRENTON

Kate Brenner

ARCADIA
PUBLISHING

Published by Arcadia Publishing
Charleston, South Carolina

Printed in the United States of America

Library of Congress Control Number: 2013952072

For all general information, please contact Arcadia Publishing:
Telephone 843-853-2070
Fax 843-853-0044
E-mail sales@arcadiapublishing.com
For customer service and orders:
Toll-Free 1-888-313-2665

Visit us on the Internet at www.arcadiapublishing.com

I dedicate this book to my enduring little champion, Riley Tayte Brenner, who—at age five—lovingly took an interest in Momma's book and supported its creation.

CONTENTS

ACKNOWLEDGMENTS

I would like to thank the reliable, exciting, and endless vaults at the Library of Congress, and the tireless staff continuously cataloguing this country's historical treasures. I would also like to thank my mother, Genie Ford, without whom this would not be possible. A thank-you goes to Bart Gamble, who never let me forget my worth.

I would also like to thank Roy Anderson for his dedication to preserving his beautiful building on Main Street, the Anderson Building, and for his devotion to his family history and his generosity in sharing his information. I thank Robert Lawrence, who has also generously supplied information about Carter Hall.

I give thanks to the John Gott Library staff in Marshall for opening their wondrous supply of archives to me with endless cheer and enthusiasm.

Frances Allshouse, director of the Old Jail Museum in Warrenton, has been invaluable in my research efforts, and she is truly irreplaceable with her endless knowledge about Fauquier County history and her grace in sharing it.

I also want to extend gratitude to the librarians at the Warrenton Library who are always helpful during my time in the wonderful Virginiana Room, where I cannot help but feel privileged as I leaf through some of the rarest books in Fauquier County.

INTRODUCTION

Warrenton, Virginia, a busy residential and commercial area just 60 miles southwest of Washington, DC, may seem just like any other Northern Virginia town—there are big name department stores, coffee shops, and plenty of strip mall real estate. Peek behind the big curtain of development and see that inside the heart of this emerging city lies a magnificent treasure—a cache of rich American history, architecture, celebrities, and even a few juicy secrets. Warrenton is the type of town that makes us yearn for the possibility of time travel because being in the historic district makes it seem like such a possibility. Within minutes, you can go from the Home Depot to the majestic courthouse, tiptoe through the iconic Old Jail and its rumored ghosts, and listen to the tower bell chime every hour.

Before colonization, English explorer John Smith documented Fauquier County as home to several Native American peoples, who would all disappear by the mid-18th century with the advent of Europeans. The Fauquier Historical Society houses several thousand Native American artifacts, and many are on display at the Old Jail Museum.

Warrenton began as a small crossroads marked by the Red Store, a trading post built before the 1760s at the junction of the Falmouth-Winchester and Alexandria-Culpeper roads. The settlement would grow to a courthouse community, located on 71 acres donated by Richard Henry Lee in 1790, and would soon become known as Fauquier Courthouse. During the Revolutionary War, Gen. Joseph Warren, the famed character who sent his good friend Paul Revere on his historic ride, was killed at the Battle of Bunker Hill; Paul Revere was a dentist and was able to identify the exhumed body of Warren by two false teeth he had placed in his jaw, which was the first known dental forensic investigation. Warren Academy was erected in his name.

In 1797, the town would be renamed Warrenton and would become the county seat of government. Because of this designation, Warrenton was graced with elegant buildings that were home to many judges and lawyers throughout the 204 years it would remain the county seat, and so many of these figures were direct contributors to the construction of America after the Revolutionary War. The Old Jail Museum, home to the Fauquier Historical Society, is one of the most perfectly preserved relics of the original town and contains a collection of artifacts that gives great insight into Warrenton over the past 200 years. It is also notorious for paranormal activity; many undeniable ghosts have been spotted lurking inside its walls.

Throughout the centuries, Warrenton has been home to people who played significant roles in shaping today's Constitution and legal system. Richard Henry Lee not only donated the land for the town, but also was instrumental in the creation of Virginia's Declaration of Rights and was the presenter of the resolution to the Continental Congress. William "Extra Billy" Smith, a Warrenton native, was responsible for legislation allowing counties to establish free public school systems receiving state funds.

Warrenton was often the choice town for occupation by Union soldiers during the Civil War. The town consistently received, treated, and most-often buried the sick and injured sent from

the battlefield by rail. Warrenton changed hands over 67 times during the entire war. Col. John S. Mosby, known as the legendary "Gray Ghost," was a town resident and is buried in the town cemetery. Mosby and his rangers were responsible for their impressive and successful guerrilla-type raids on Union camps. Mosby disbanded his men at the end of the war near Warrenton and is honored by a monument that stands next to the Old Jail.

In 1790, slaves were already 37 percent of Fauquier County's population; between 1800 and 1850, hundreds of criminal or runaway slaves were sold on the courthouse steps. After the Civil War, the African American population of Warrenton struggled to integrate themselves into society after centuries of enslavement; however, despite their hardships, they established schools, churches, a black Masonic society, a fraternity, and Fauquier's Freedman's Bureau headquarters in Warrenton and surroundings.

On the outskirts of town, along the Rappahannock River, lies the grand Fauquier Springs Resort, known for its healthful sulfur springs, grand 19th-century balls, and elegant accommodations that attracted prestigious visitors from all over the country, including many important figures from Washington, DC. It was burned in the crossfire during a Civil War skirmish but was reclaimed and renovated in the early 20th century by Walter Chrysler. Even a castle lies on the Warrenton horizon; the great stone Castle Murray was the site of Civil War occupation and inspiration for the novel *The Circular Staircase.*

The equestrian population shaped much of the culture in Warrenton for many years, from the running of the famous Gold Cup steeplechase to the historic Warrenton Horse Show. The hunt can still be seen traversing the fields of large plantations; it and other events are not the relics of a bygone era because century-old traditions still hold strong all over Fauquier County, giving it a unique, historical feel. The Warrenton Horse Show still exhibits on the same grounds it did over 100 years ago, when it was in Extra Billy Smith's backyard. Through the Great Depression, two world wars, and a devastating fire at the beginning of the 20th century, the equestrian culture prevailed and has remained a common theme in town.

Beyond the Civil War relics and the sophisticated foxhunting culture lie stories ranging from the macabre to the top secret—Warrenton has its share of ghost stories and even a classified CIA communications facility. From skeletons in the Odd Fellow's hall to a high-profile crime of passion, the story of Warrenton goes much deeper than the historic architecture. The town offers ghost tours during the fall, a beautiful Christmas parade during the winter, and a farmers' market during the spring and summer. The old-town feel has never been lost thanks to conservation by the National Register of Historic Places in 1972, which includes 323 historic Warrenton buildings. The town still maintains its same layout displayed on the 1811 grid plans, with its impressive combination of residential and commercial buildings representing three different centuries of architecture. The town may be modernized on the outside, but peel back the layers, get inside the town, and find the story of America—from its first declaration to today's changing world.

One

EARLY YEARS AND THE REVOLUTIONARY WAR

Before European colonization, Fauquier County was an open frontier, covered by rich, fertile soils and abounding with wild game and fish. The Manahoac tribe inhabited several settlements along the Rappahannock River, and obscure hunting trails were the only known travel routes before colonization. The Treaty of Albany in 1722 mandated that Native Americans would stay west of the Blue Ridge as long as settlers remained in the river valley, but the white man characteristically breached the agreement, and the natives were pushed farther west. Early settlers also made their homesteads by the Rappahannock River, and settlements were comprised mostly of colonists from the North who were attracted to the fertile lands and relatively temperate climate. By the early 1700s, several dirt roads and "ordinaries," which were Colonial-period rest stops and inns, existed in remote areas of Fauquier County. By the 1730s, a large percentage of the population was slaves, sent by landowners to farm the land in their absence.

Fauquier County was originally part of Prince William County, until it was sectioned off and officially chartered in 1759. Both counties were derived from the Northern Neck Proprietary, owned by the 6th Lord of Fairfax. In 1718, Thomas Lee, of the powerful Lee family in Virginia, owned 4,200 acres in Fauquier County that he acquired when he was land agent for the Fairfax proprietary. He fathered Richard Henry Lee, who would inherit this land and donate part of it to establish Warrenton. He was also a signer of the Declaration of Independence.

Prior to receiving its current title of Warrenton, named after the Revolutionary War general Joseph Warren, the town was established as the Red Store in 1759 for the tavern that served everyone from weary travelers to political dignitaries. The county was named for Francis Fauquier, lieutenant governor of Virginia in 1758, who was described as generous, liberal, and elegant, and according to Thomas Jefferson, he was the "ablest man who ever took office."

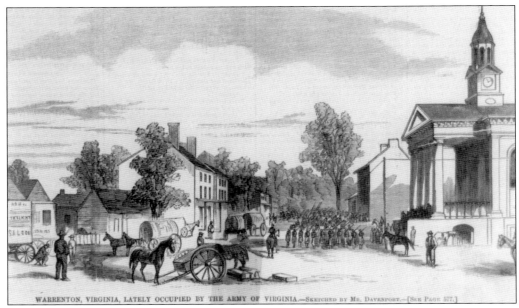

WARRENTON, VIRGINIA, LATELY OCCUPIED BY THE ARMY OF VIRGINIA.—Sketched by Mr. Davenport.—[See Page 577.]

Warrenton has developed into a busy urban area since the 1700s, but the nucleus of Old Town Warrenton still contains remnants of the tiny settlement it once was. Thanks to many historical societies in Fauquier County, the town's story has remained deeply preserved. Many significant events, such as the Civil War, are recorded in great detail, though Warrenton had a much older story to tell long before European settlement. (Library of Congress.)

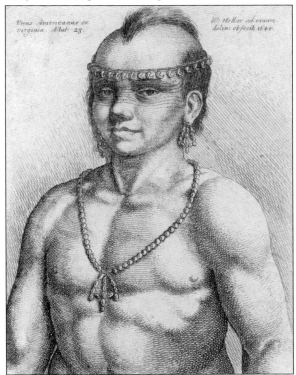

The Manahoac Indians, a Siouan tribe, inhabited Fauquier County up to the mid-17th century. Documented accounts of the Manahoac are rare; they avoided the Europeans and were in ongoing competition with other tribes. By the 1670s, there were no recorded accounts of these particular tribes. The 1607 depiction of a Virginian native, carved by Englishman Wenceslaus Hollar, is one of the earliest portraits of a Native American. (Library of Congress.)

10

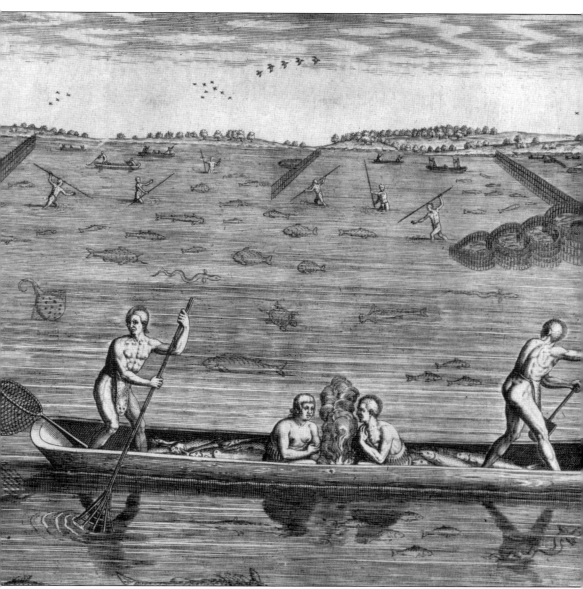

Many parts of Fauquier County were hunting grounds for Native Americans during the 17th century. They were pushed westward, rerouting at one point just above Auburn, the location of Castle Murray, described on page 42. That re-routed Shenandoah hunting path led to important fishing grounds on the Rappahannock River. Settlers, consisting of mostly cattle thieves, overran this path, earning it the nickname of "Rogue's Road." An engraving from the 16th century shows natives fishing in the Virginia rivers, with spear fishermen on shore and men and women in a canoe. (Engraving by Theodor de Bry; Library of Congress.)

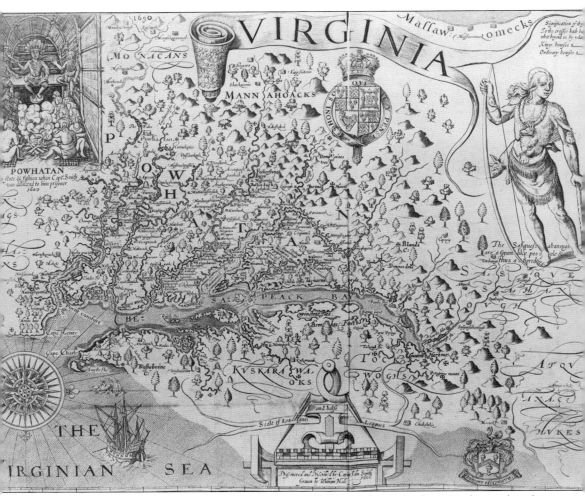

One of these Manahoac settlements existed at Elk Run, where the first Anglican church in Fauquier County was built in the 1750s. The first rector of this church was Reverend Keith, whose grandson was Chief Justice John Marshall. Two subtribes, the Tanxnitania and the Whonkentia, inhabited the shores of the Rappahannock River outside of Warrenton. The Algonquin word "Rappahannock" translates to "people of the ebb and flow stream." By using information given to him from a Manahoac man named Amoroleck, John Smith mapped three Manahoac settlements along the Rappahannock River, as seen here in the upper section of his 1612 map. The Manahoacs had attacked Smith's party because they believed the whites represented a threat. Amoroleck was left behind, wounded, and Smith's men rehabilitated him. Amoroleck more or less served as an olive branch between Smith and the Manahoacs, though the natives were rightfully wary. (Graven by William Hole; Library of Congress.)

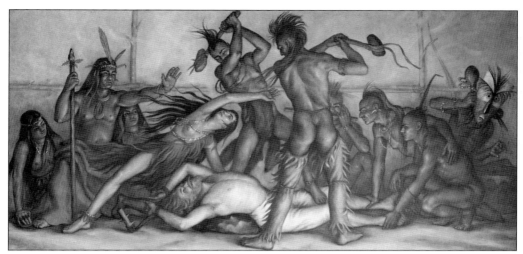

Smith is most famous for his relationship with Pocahontas, but his documentation of the Manahoacs is invaluable. The information obtained through his relationship with Amoroleck is among the sparse documentation of Native Americans around Warrenton and the Rappahannock River, other than artifacts found at dig sites. This painting, hanging in the Richmond Courthouse, shows Pocahontas saving the life of Captain Smith. (Library of Congress.)

In the 1772 Treaty of Albany, the Iroquois agreed to transfer their territory to the Shenandoah while the settlers agreed to remain in the valley. The settlers broke their end of the agreement, and the natives were pushed out of Fauquier County forever. Hendrick, or Tiyanoka, an esteemed Mohawk sachem, or chief, negotiated peace between the Six Nations and Great Britain at the Albany Treaty Conference. He is pictured here, in elaborate European dress, around 1775. (Library of Congress.)

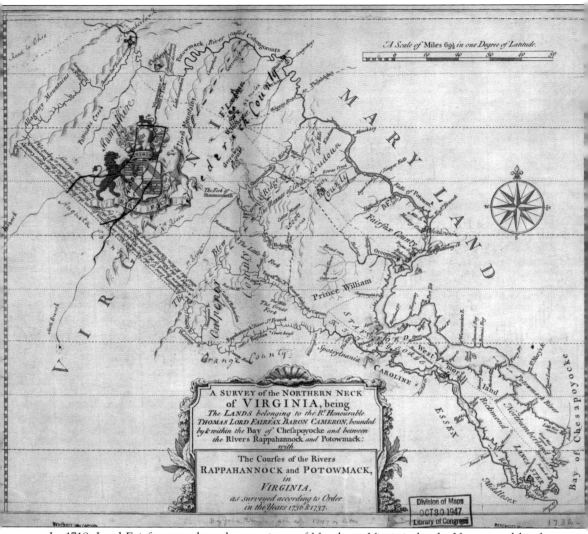

In 1718, Lord Fairfax was the sole proprietor of Northern Virginia lands. He granted land to Thomas Lee, documented in a deed in King George County Court. Upon Lee's death, the deed states, "Honorable Thomas Lee Esquire, late President of Virginia, was granted land by Proprietors Deed. Thomas Lee devised this deed to his son, Richard Henry Lee." Richard Henry Lee would later grant and plot the land that would become Fauquier Courthouse and, eventually, the town of Warrenton. The lands of Lord Fairfax were defined between the Rappahannock and Potomac Rivers, known as the "Northern Neck," composed of 5,282,000 acres. A map from 1736 shows the Northern Neck of Virginia when it belonged to the Fairfax nobility. (Library of Congress.)

In 1718, Thomas Lee built Leeton Forest a few miles from town; his grandson-in-law Charles Lee lived in it while he was US attorney general from 1795 to 1801. Charles was counsel to US vice president Aaron Burr while he was on trial for treason; he was eventually acquitted. This home survived several fires but finally succumbed to one in 1921. The home was rebuilt in even grander fashion and still stands today, pictured here around 1978. (John Gott Library.)

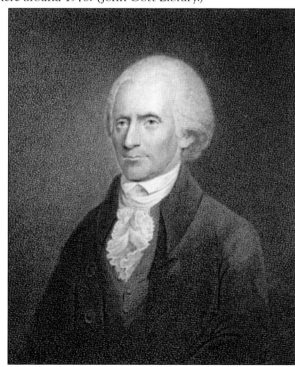

Richard Lee was one the first Americans to foresee the imminent revolution against Britian. He was a member of the opposition against the Stamp Act, claiming it "does absolutely direct the property of the people to be taken from them without their consent." Pictured is Richard Henry Lee. He was accused by his political enemies of opposing the Constitution when he suggested the idea of amendments and withdrew from the debate in 1788. (Painting by Charles Willson Peale; Library of Congress.)

Richard Henry Lee is buried in Westmoreland County, Virginia. His grave inscription reads, "Mover of the Resolution for Independence, Signer of the Declaration of Independence, President of the Continental Congress, United States Senator from Virginia; We Cannot Do Without You. (Library of Congress.)

Featured in *Independence* magazine, a sketch shows Richard Henry Lee delivering the Declaration of Independence to Americans in Independence Square, Philadelphia, on the Fourth of July. Richard Henry Lee was one of the first leaders to champion communication between the colonies, uniting them in their efforts against the British. Lee Street in Warrenton was named for him, contrary to the common misconception that it was named after Robert E. Lee. (Library of Congress.)

The transformation from trading post to town began with the construction of the first courthouse in 1764; at that time, the town was known as Fauquier Courthouse. Since the first courthouse, Warrenton has seen seven courthouses; the early four courthouses stood on the Old Courthouse General District Court site on Main Street but were lost to fire or expansion. This composite sketch from *Harper's Weekly* shows several important junctions in the area, including the Warrenton depot at the top. (Anderson Collection.)

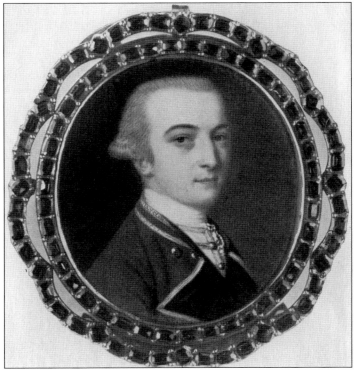

Francis Fauquier was appointed as lieutenant governor of Virginia in 1758. Though the British sent him to rule, his humanitarianism often won the people's hearts. He advocated public welfare for the mentally ill, and Fauquier County retained his name after the Revolutionary War. Considering the time, he was progressive on his views about slavery, stating in his will, "I must provide for [my slaves] at my death by using my utmost endeavors that they experience as little misery during their lives." (John Gott Library.)

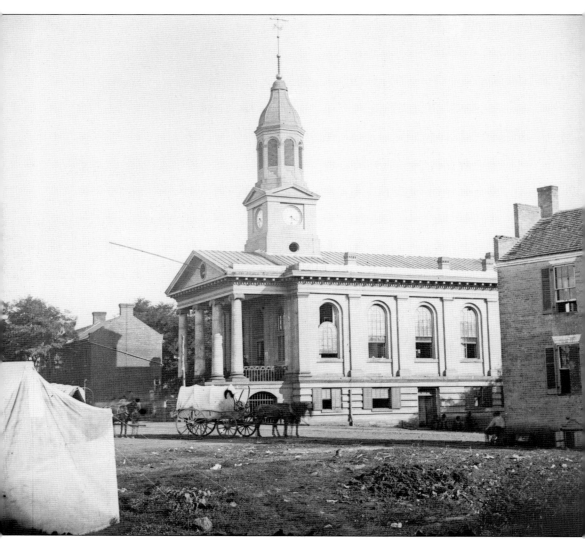

The original courthouse was a humble wood-frame building, but Warrenton's seventh courthouse is a grand structure that still houses the General District Court today. A bell was added in 1819 and still rings every hour, on the hour, throughout the day in town. Slaves were auctioned off a block of granite, which still stands between the courthouse and the Old Jail. (Library of Congress.)

The Old Jail was built in 1808, originally having just four cells. It was expanded in 1824 to include an exercise yard that doubled as a pigpen, vegetable garden, waste dump, and gallows—hangings were performed until 1896. At the beginning of the 19th century, the cells had dirt floors and barred windows without glass. In 1821, prisoners died in a jail fire; survivors were temporarily moved to the courthouse cellar. After this disaster, it was rebuilt with thicker walls, floors, and glass windows, earning the nickname "Rock Hotel." In 1824, a jailer's residence was added to the structure, including a kitchen with a bedroom above. It is the oldest, best-preserved jail in Virginia and serves as a museum for the Fauquier Historical Association, which took it over in 1966 when it closed. It is full of paranormal happenings, which are recorded in the book *Ghosts in the Old Jail,* written by museum director Frances Allshouse and available at the museum. (Anderson Collection.)

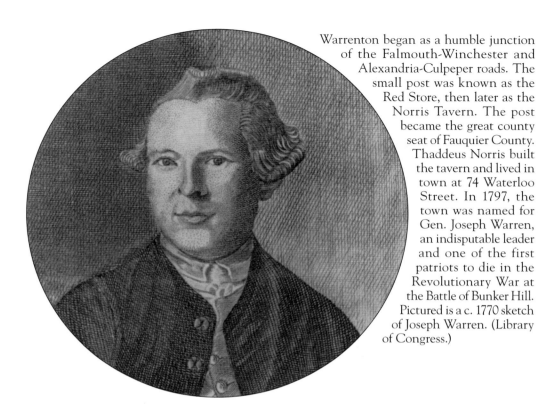

Warrenton began as a humble junction of the Falmouth-Winchester and Alexandria-Culpeper roads. The small post was known as the Red Store, then later as the Norris Tavern. The post became the great county seat of Fauquier County. Thaddeus Norris built the tavern and lived in town at 74 Waterloo Street. In 1797, the town was named for Gen. Joseph Warren, an indisputable leader and one of the first patriots to die in the Revolutionary War at the Battle of Bunker Hill. Pictured is a c. 1770 sketch of Joseph Warren. (Library of Congress.)

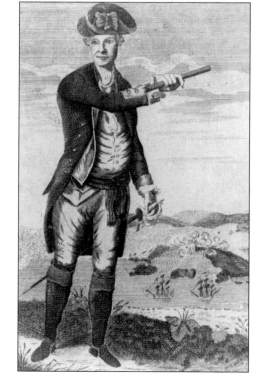

Joseph Warren was a savvy radical organizer before the war, declaring that patriotic Americans should ignore immoral British laws. It was Warren who alerted Paul Revere before his famous ride to spread word of British advancement. He was commissioned second major general in 1775, but instead volunteered at the battle at Bunker Hill; he gave his life that same year defending a remount so his men could escape. The general is depicted in this 1781 engraving. (Engraving by John Norman; Library of Congress.)

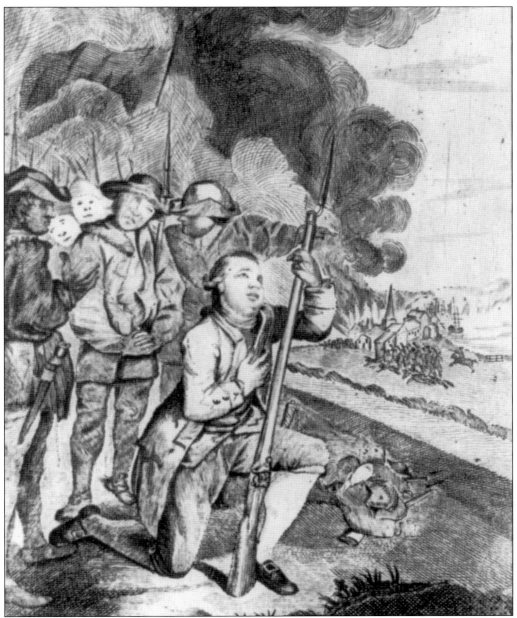

Warren received a lethal shot to the head at Bunker Hill and was tossed gracelessly in a ditch by British soldiers after they removed his uniform and made mincemeat of him with their bayonets. His dear friend Paul Revere led the exhaustive search for Warren's remains. The only method of identification was the two false teeth that were wired into Warren's mouth by Revere (also a dentist) in the previous year. This was the first recorded forensic identification of a body using dental information. Warren's little brother, also Joseph Warren, founded Harvard Medical School after apprenticing under his big brother. A truly amazing yet relatively unknown hero, Dr. Joseph Warren was a physician, politician, mason, and soldier before his 34th birthday. This print depicts Warren's dramatic death. (Library of Congress.)

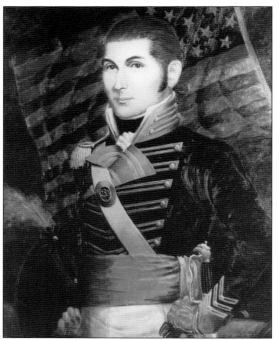

Presley Neville O'Bannon, known as the "Hero of Derne," was born in Fauquier County in 1776. O'Bannon is famous for his bold rescue of US prisoners at Derne in eastern Libya, when the USS *Philadelphia* wrecked on the shores of Tripoli. His heroic service is commemorated in the Mameluke sword worn by US Marine Corps officers; the Mameluke was presented to O'Bannon in appreciation for services rendered on "the shores of Tripoli." (Library of Congress.)

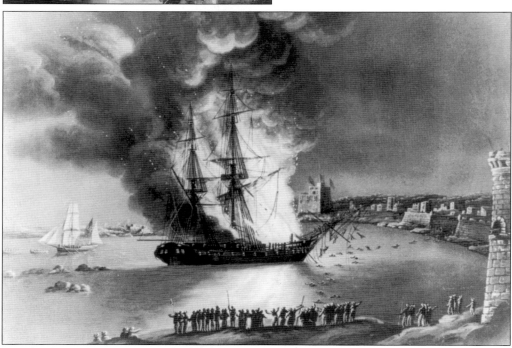

Tripoli, after making threats to the United States for higher tributes, cut down the US flag in front of the consulate—and America declared war. When the USS *Philadelphia* wrecked and the crew was captured, Tripoli refused the $100,000 offered in ransom, leading to O'Bannon's heroic rescue. Pictured is the frigate USS *Philadelphia* burning off the shores of Tripoli on February 16, 1804. O'Bannon was the first to hoist an American flag in victory on foreign soil. (Library of Congress.)

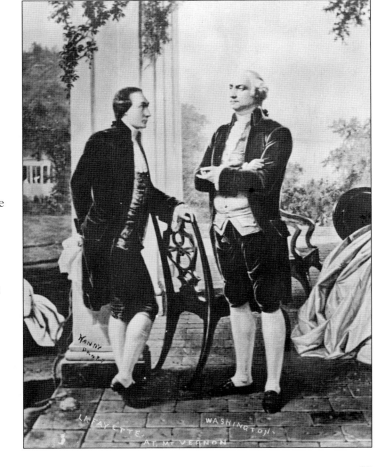

An illustration in the *American Weekly* in 1958 dramatizes O'Bannon's battle to rescue the prisoners; the caption reads, "O'Bannon and his men finally got over the wall of the fort and dropped, shooting, fighting and kicking, into a waving sea of scimitars." O'Bannon's fight inspired the words "to the shores of Tripoli" in the Marine Corps hymn. (Old Jail Museum.)

In 1825, General Lafayette visited Warrenton on the town's invitation to speak to the citizens about his experience at war in America, fighting alongside George Washington. After his address, he stayed in the Norris Tavern, which later became the famous Warren Green Hotel. This is a sketch of General Lafayette and his friend and ally, George Washington, at Mount Vernon. (Library of Congress.)

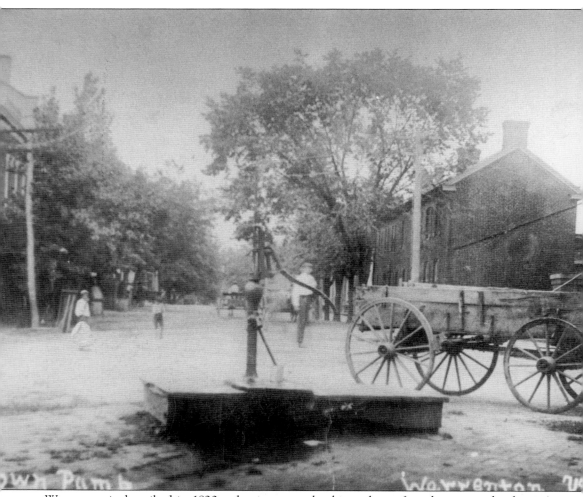

Warrenton is described in 1820 as having several cabinet shops, four doctors, and a dentist's office, a tannery, wagon manufacturers, a shoe factory, a sawmill and gristmill, a ladies' fashion boutique, a clock maker, a furniture maker, and even fire insurance sales. Stephen McCormick of Auburn invented a revolutionary plow that boasted sales of over 10,000 units in Fauquier County. McCormick's plow was an early standardization of replaceable parts, which is central to manufacturing all kinds of equipment today. Many people during this era forewent bathing, which was thought to be a health hazard since bathwater was often contaminated with sewage, and rarely was the connection made between dysentery and filthy water. Even after sewer systems were designed, the stench made homes uninhabitable before engineers figured out how to evade sewer gas. Pictured is the town "pump"; before indoor plumbing, Warrenton residents communally collected their water at a central location. (Old Jail Museum.)

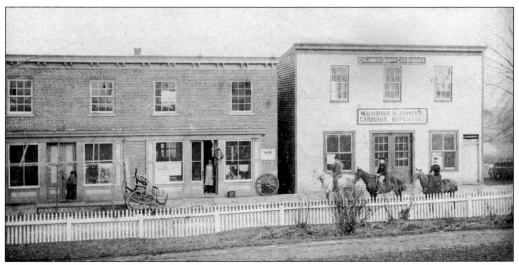

Pictured in the late 19th century is the George Booth Carriage Repository. George operated this repository for almost 57 years, excluding the time he served under Captain Brooks during the Civil War. He passed away in 1906 as the last original founder of the Warrenton Baptist Church. A fire behind the repository burned the Episcopal church in 1910. (Old Jail Museum.)

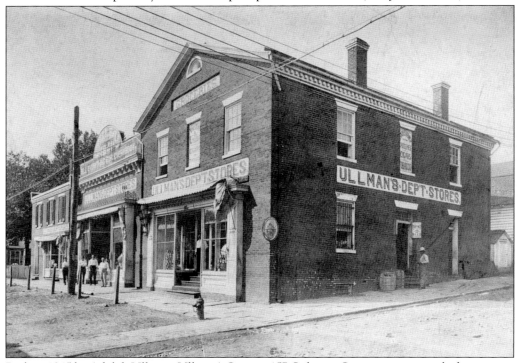

Built in 1845 by Adolph Ullman, Ullman's Store at 157 Culpeper Street was an upscale department store, indicative of the growing economic wealth in Warrenton. It sold china, liquors, and even riding attire. At age 15, John Barton Payne was employed here as a store manager. Payne was a well-known humanitarian and chairman of the Red Cross until 1921. The store's slogan read, "Sell everything to everybody." (Old Jail Museum.)

Adolph and Caroline Ullman were the founders of the Ullman's mercantile. The 51–54 Lee Street warehouses were expansions of the Ullman's success; the name Ullman is still etched into the sidewalk in front. They are now home to a salon and music store. The Ullmans built the annexes to the Warren Green Hotel when they purchased it, and it was one of the buildings sacrificed to dynamite to halt the Great Fire of 1909. (Old Jail Museum.)

The Ullmans erected their home, the Ullman House, away from their commercial property, which was a clear symbol of their financial success. John Spilman built this beautiful home at 157 Culpeper Street in 1857. The Ullmans were Jewish; note the Star of David on the roof. (Kate Brenner.)

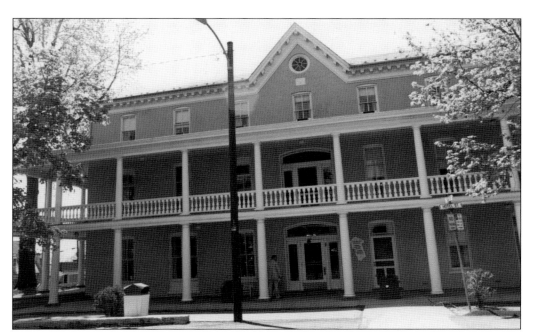

After Ullman's death in 1883, his widow, Caroline Ullman, ran the business; it became the largest and longest-running business in Warrenton, operating for over 100 years. Joe and Herman Ullman purchased and restored the Warren Green Hotel. The hotel remained in the family until 1960, when it was forced to close due to competition. The hotel has sometimes been referred to as "Little Waldorf," and at the turn of the 20th century, the Warren Green was the central location for anyone who wished to meet in town. Pictured in the mid-20th century is the Warren Green Hotel. (Old Jail Museum.)

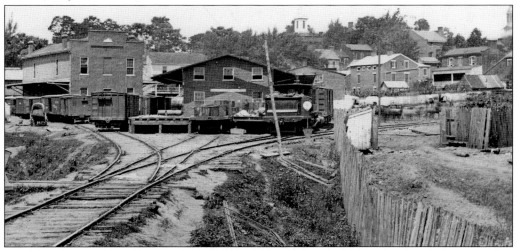

After construction of the Warrenton Junction in 1852, a rail branch line off the Orange & Alexandria Railroad served the town. The nine-mile branch line also served stations at nearby Meetze and Casanova. As the Rappahannock River Canal diminished in usefulness and Fauquier County citizens discovered the efficiency of the iron horse, the railroad became an integral part of Fauquier County's development. The Warrenton depot yard is pictured here in 1862. (Photograph by Timothy H. O'Sullivan; Library of Congress.)

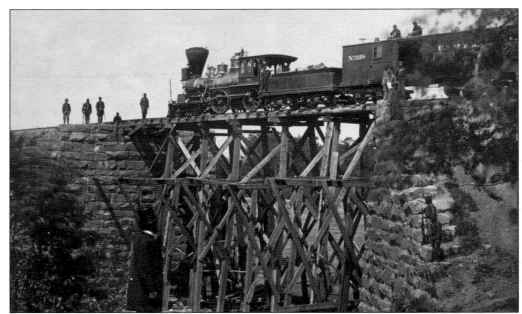

The advent of the railroad in Fauquier County brought fashionable visitors to the upscale Fauquier Springs Resort, making a distinguished connection to the area outside rural Fauquier County that it never saw before. It served as support for a growing agricultural economy and industrial exports and as an alternative for the sluggish and unreliable canal systems of the Rappahannock River. Pictured is an engine named *Firefly* atop a trestle bridge on the Orange & Alexandria line in 1864. (Photograph by Andrew J. Russell; Library of Congress.)

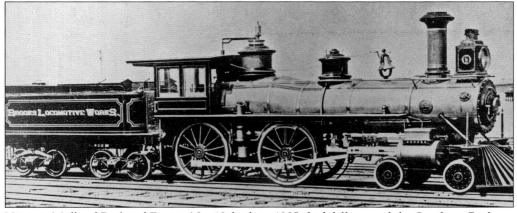

Virginia Midland Railroad Engine No. 19, built in 1885, faithfully served the Southern Railway, probably stopping at the Warrenton depot many times throughout its career. This specific engine was not scrapped until 1925. The 14th US president, Franklin Pierce, would use this line to visit the Virginia countryside, as did Eleanor Roosevelt, who visited Fauquier County women to discuss the Farm Housing Service. The Warrenton depot was often the last place a parent would see their son; the Warrenton Rifles waved goodbye from trains at the depot during deployment in World War I. The Warrenton depot was not renovated until 1908, and in 1941, the last passenger train would depart Warrenton forever. In 1970, the final freight train left the depot's yard. This would not signify the end of the depot, however; in 1978, it was purchased and renovated to become a successful restaurant, still in operation today. (John Gott Library.)

This 1939 photograph displays the beautiful home and gardens of Belvoir, a magnificent estate in The Plains outside of Warrenton. Fairfax Harrison, then president of the Southern Railway, owned this home in the early 1900s. He even had his own rail line and station on the property so he could catch the train to his Washington, DC, office. By 1916, Southern Railway ran its trains on 8,000 miles of track through 13 states. (Photograph by Francis Benjamin Johnston; Library of Congress.)

This is another 1939 photograph of the beautiful Belvoir property in The Plains. The front portico can be seen in the background. (Library of Congress.)

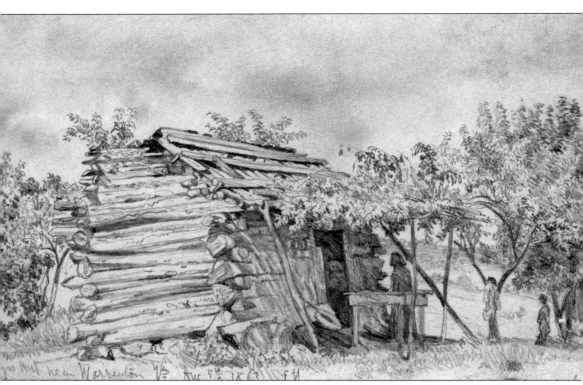

Not all of Warrenton's economic growth and prosperity can be attributed to the rails. Thousands of slaves labored on plantations throughout Fauquier County and were banned to the corners of society, enduring horrendous treatment. The war would soon change the lives of all Fauquier County residents, for better and for worse, no matter their race. Blacks who enlisted in Federal service suffered. Of the roughly 200,000 enlisted, it is estimated 33,000 blacks were killed, and only 4,000 of these deaths were combat related, indicative of the conditions. Men died from diseases—diarrhea, dysentery, pneumonia, tuberculosis, malaria, and smallpox. Infected blacks were even sent to expose enemy camps to spread the disease. Freed blacks would face Reconstruction with courage, building churches and schools. This was the only way to integrate themselves into society, and they did so in the face of extreme adversity. Edwin Forbes documented a typical slave cabin close to Warrenton in an 1863 sketch. (Library of Congress.)

Two

THE CIVIL WAR

Though Warrenton never saw any battles within town limits, it was known as the "Debatable Lands," as it switched hands between Confederate and Union occupation over 60 times during the war. Even though the town streets did not experience action, Warrenton saw enough bloodshed and suffering. Many militia members from Warrenton households would ride to Harper's Ferry as vigils in the John Brown case—the uprising that is thought to have pushed the nation the last few steps toward all-out war. Like most Civil War–era settlements in Fauquier County, every church and even many private homes were transformed into hospitals at some point to accommodate the thousands of wounded soldiers who arrived by train and wagon. Some of the most famous names from the Eastern theater of the war made their bases in Warrenton, including General McClellan, who gave his parting speech from the balcony of the Warren Green Hotel when he was dismissed from duty by Lincoln, and General Burnsides, who was his replacement. Some military leaders even remained after the war ended to practice law and/or become politicians, including the elusive Gray Ghost, Col. John S. Mosby. Mosby had led his famous partisan Rangers on highly successful guerilla-style attacks against Union forces. Most of Warrenton's military and political leaders during this period were slave owners and pro-secession—a stark contrast from the neighboring Loudoun County, which had a large Quaker population. Because Fauquier County depended heavily on agriculture, the upper classes were in no way willing to give up their slaves. Another surprising factor in the reluctance was the position of the Southern churches, which also protected slavery—one Southern reverend is quoted as stating, "Abolitionists regulate the duties of this and all other relations among men—but they cannot abolish any relation, ordained or sanctioned of God, as is slavery."

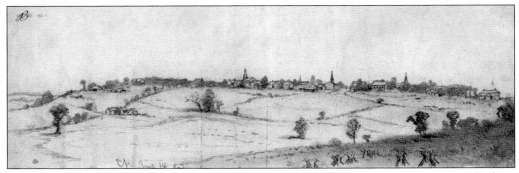

This is a sketch by Edwin Forbes in 1862 of Warrenton, looking from the east. Edwin Forbes's sketches would become instrumental in understanding history in Fauquier County during the Civil War; they gave a personalized insight into the bloody battles he recorded. (Library of Congress.)

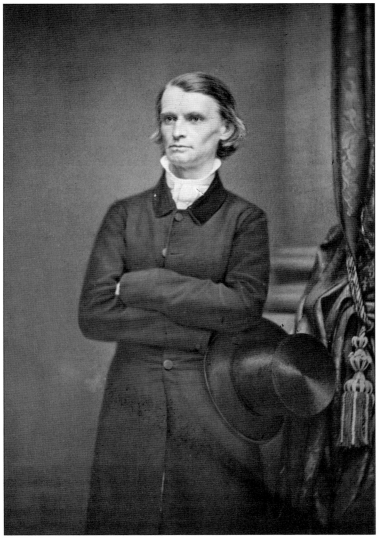

Virginia governor Henry Wise, from 1833 to 1844, called upon Fauquier County and Warrenton to draw up their defenses by forming different militia groups, anticipating the South's secession. Wise himself was given the title of brigadier general in the Confederate army, despite his lack of military training. His performances were abysmal until he was credited with saving the city while commanding his brigade at the First and Second Battles of Petersburg. (Engraving by Adam B. Walter; Library of Congress.)

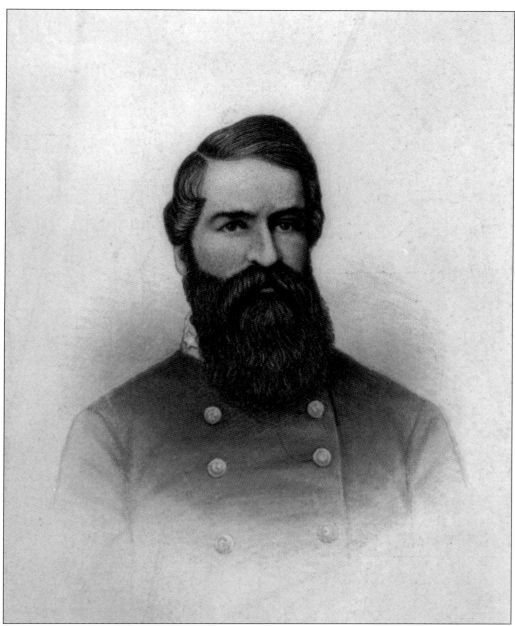

Turner Ashby was born in 1828 and raised in Fauquier County. His Mountain Rangers were formed to protect the railroad before the Civil War erupted. As brigadier general, he provided security during John Brown's trial and execution in Harper's Ferry, West Virginia. He was known as the Black Knight of the Confederacy; his black hair and proclivity for black horses earned this name. During battle in 1862, his horse was killed, but Ashby continued charging on foot and was later shot through the heart. (Library of Congress.)

Sensing the rising tension between the North and South just before the Civil War, the Warrenton Rifles were formed to help guard the county seat. Rumors of slave rebellions led to the formation of the Mountain Rangers, Warrenton Home Guard, Warrenton Rifles, and the Black Horse

Cavalry. The Black Horse Cavalry would go on to serve as Stonewall's bodyguards, scouts, and aides. James Keith, one of the original Black Horse cavalrymen, went on to become chief justice of the Virginia Supreme Court. (Old Jail Museum.)

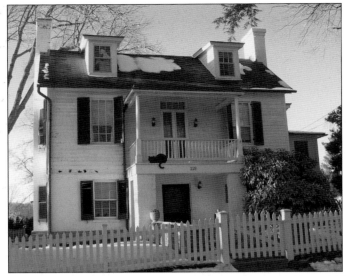

John Quincy Marr was born in Warrenton—a pro-slavery, pro-secession political figure who served as sheriff in Fauquier County for two years. He formed the Warrenton Rifles after the John Brown incident in Harper's Ferry. He is most popularly known as the first Confederate soldier to die at the hands of a Union soldier, when he was shot and killed at the Battle at Fairfax Courthouse on June 1, 1861. This photograph shows the Marr House at 118 Culpeper Street. (Photograph by Kate Brenner.)

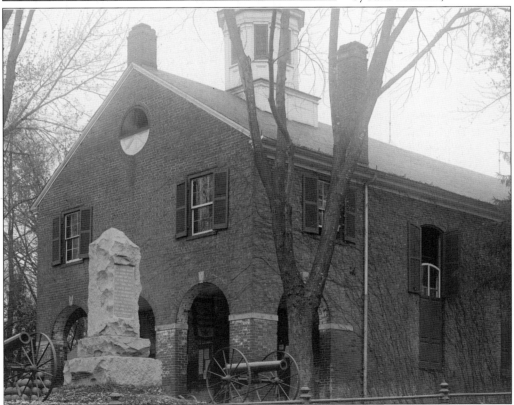

This photograph shows the monument in the lawn of the Fairfax Courthouse memorializing John Quincy Marr. Erected in 1904, the inscription reads as follows: "This stone marks / the scene of the / opening conflict / of the war of / 1861–1865, when / John Q. Marr, / Captain of the Warrenton / Rifles, who was the / first soldier killed / in action, fell 800 ft. / S. 46 W. Mag. of this / spot, June 1st, 1861." This photograph was taken in 1918. (Library of Congress.)

William Payne, a graduate of the University of Virginia, established a law practice in Warrenton in 1851. He also anticipated the disbanding of the Union in 1858, and suggested the formation of the Black Horse Cavalry militia. Despite his qualifications, he enlisted as a private, yet became captain in 1861. Wounded and imprisoned during battle, his wife, Alice Fitzhugh Dixon Payne, was told he had perished. Alice, in disbelief, searched desperately for her husband. After finally locating him in an obscure hospital, she brought him home and nursed him back to health. (Library of Congress.)

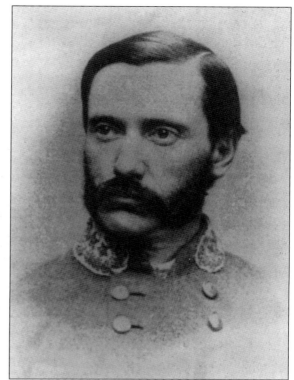

Payne was wounded and imprisoned twice more after many successful charges with the Black Horse Cavalry. He was accused of being involved in Lincoln's assassination and was the last of the troop to be paroled. After the war, he continued to practice law as counsel for the Southern Railway Company. Pictured is General Payne's home on 114 Lee Street, where the Black Horse Cavalry was formed; the cavalry also held reunions here. (Old Jail Museum.)

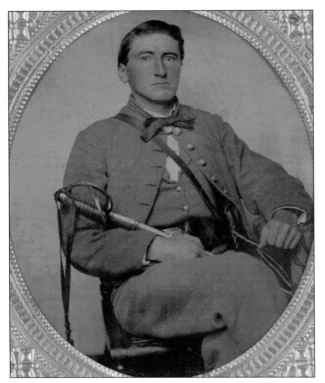

Alexander Dixon Payne, son of Richard Payne and Alice Fitzhugh Dixon Payne, enlisted in the Black Horse Cavalry in 1861. Gen. Stonewall Jackson commended him for his services during battle. After the war, he became a distinguished member of the Warrenton Bar, served as a delegate to the Virginia General Assembly, and was a three-time mayor. He and John Mosby were imprisoned briefly in the Warrenton jail after attempting to duel despite a ban in Virginia. (Library of Congress.)

Gen. J.E.B. Stuart received a mortal wound at the Battle of Yellow Tavern north of Richmond, Virginia. Union soldier John Huff sent a bullet through Stuart's abdomen, which exited through his back. General Stuart suffered greatly waiting for his wife, and when she arrived, his final words were "I am resigned; God's will be done." Stuart is buried in Richmond's Hollywood Cemetery, pictured here in 1865. (Photograph by The War and Exhibition Company; Library of Congress.)

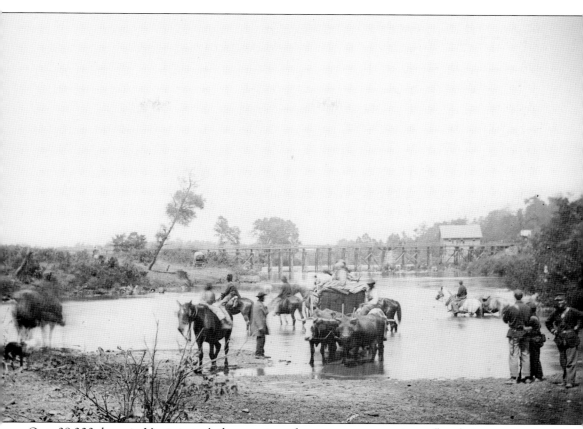

Over 38,000 slaves in Virginia took the eruption of war as an opportunity to flee their masters or join the Union troops in battle. With being in the front lines, there are some types of hardships for men, black and white, to endure. Shown here are fugitive slaves crossing the Rappahannock River at Tinpot Run Ford in this 1863 photograph by Alex Gardner. These slaves took advantage of the chaos and fled following Union general John Pope's retreat from Catlett's Station. Pope's army of 55,000 men had fallen back from the Rapidan River near Culpeper to a point on the Rappahannock River near the Fauquier Springs Resort, and the exodus of soldiers from Culpeper triggered similar movement in the slaves. They saw it as an opportunity to emancipate themselves, forging into uncertainty and a world at war. In the background, the Orange & Alexandria Bridge can be seen in front of a gristmill. (Library of Congress.)

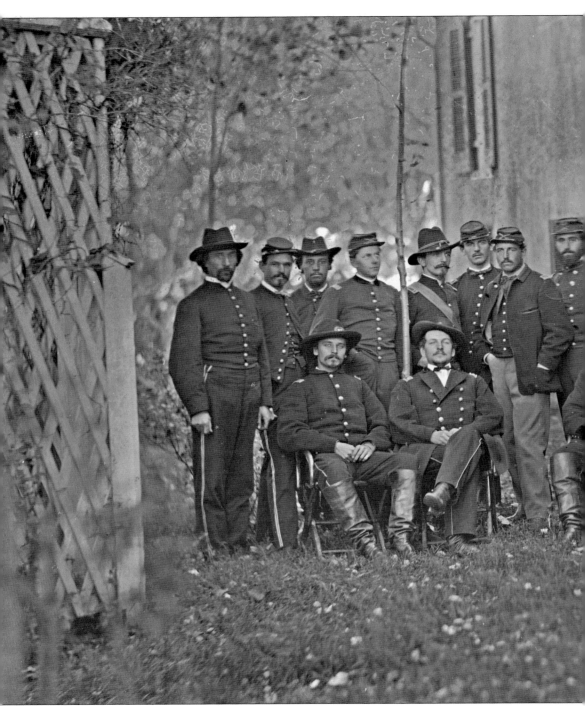

Listed in this image from 1863 in Warrenton are, from left to right, (sitting) Lt. Col. Albert S. Austin, chief commissary; Col. George A. H. Blake, 1st US Cavalry; Major General Pleasonton; Col. Charles R. Smith, 6th Pennsylvania Cavalry; and Capt. Henry B. Hays, 6th US Cavalry; (standing) Lt. Ira W. Trask, 8th Illinois Cavalry; Lt. George W. Yates, 4th Michigan Infantry; Lt.

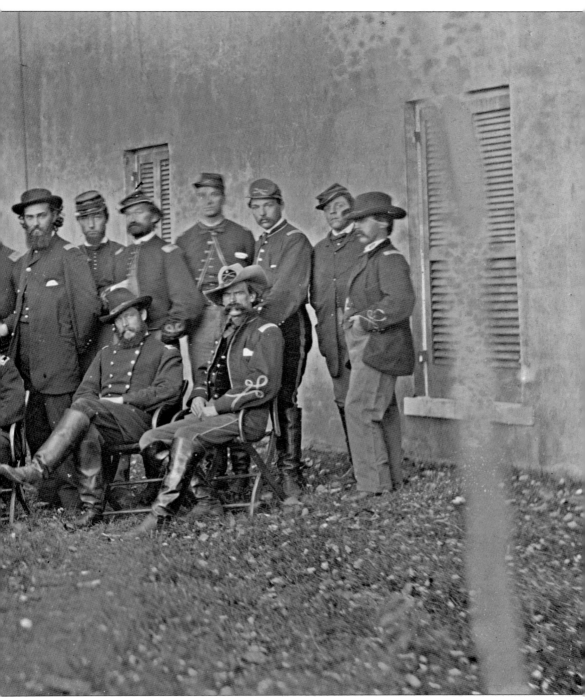

James F. Wade, 6th US Cavalry; Lt. Henry Baker, 5th US Cavalry; Lt. Leicester Walker, 5th US Cavalry; Capt. Charles C. Suydam; Lt. Daniel W. Littlefield, 7th Michigan Cavalry; unidentified; Lt. Curwen B. McLellan, 6th US Cavalry; unidentified; and Lt. G. Irvine Whitehead, 6th Pennsylvania Cavalry. (Library of Congress.)

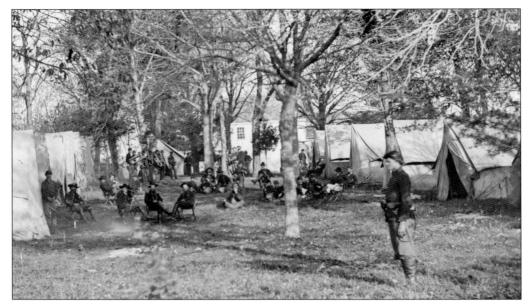

Castle Murray, or Melrose Castle, is a registered historic landmark about six miles east of Warrenton. Built in 1850 by Dr. James Murray, it was known as Auburn and used by both Union and Confederate forces as a camp and hospital during the war. General Pleasonton and his troops made their camp on its lawn. Here, the troops enjoy a bit of evening music before the bloody battle where many would meet their end. (Library of Congress.)

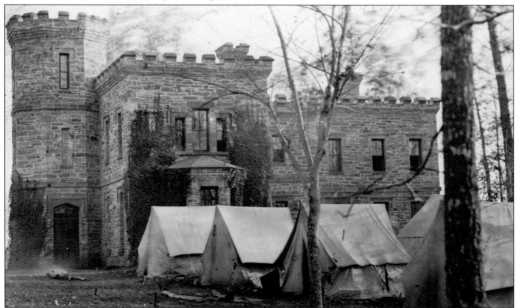

Author Mary Rinehart spent a summer at the castle, and the dramatic spiral staircase served as her muse when she wrote *The Circular Staircase*. This novel was made into the movie, *The Spiral Staircase*. Rinehart popularized the phrase "the butler did it," though without actually writing the phrase; in her novel *The Door*, the butler turned out to be the guilty one. Timothy H. O'Sullivan took this photograph in 1863. (Library of Congress.)

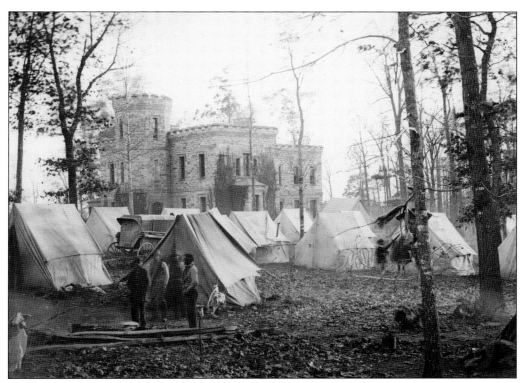

On the morning of October 14, 1863, Gen. J.E.B. Stuart's cavalry attacked Union brigades who were brewing coffee at their camp near Auburn. Thinking they had the advantage with their surprise attack, Stuart's cavalry found themselves suddenly outnumbered and woefully retreated. Pictured is the Auburn camp around November 1863. Upon close examination, one can see black soldiers standing in front of the tents. (Photograph by Timothy H. O'Sullivan; Library of Congress.)

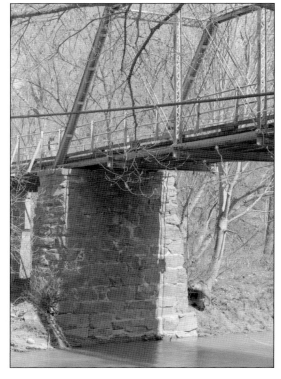

Union general John Pope was ordered to hold a line along the Rappahannock River; he built a bridge over it to prevent General Lee's advancement. By August 1862, Pope reached the Fauquier Springs Resort. Pope attempted to burn his bridge to prevent Stonewall Jackson's approach but was suddenly outflanked. This led to the Second Battle of Bull Run. The Virginia Bridge and Iron Company rebuilt the Waterloo Bridge in 1918. (Historic American Engineering Record, Library of Congress.)

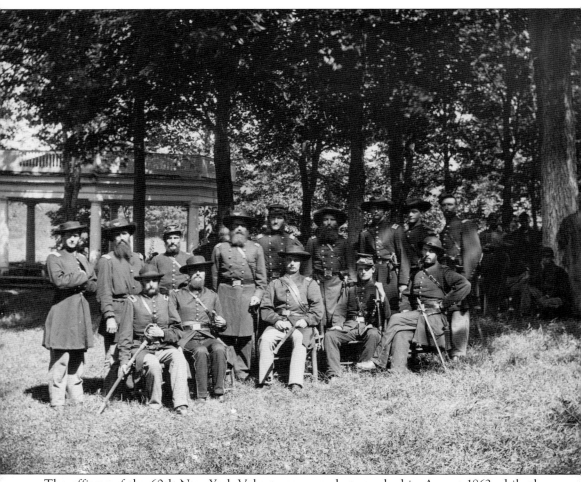

The officers of the 60th New York Volunteers were photographed in August 1862 while they occupied the Fauquier Springs Resort. The volunteers suffered a severe outbreak of typhoid fever during that summer. Dr. Gale, army surgeon, reported the following from the springs: "It was ardently hoped that the rest and conveniences afforded at this place would have a beneficial effect . . . this anticipation has been disappointed . . . in the past five days we have lost six cases, and three more will doubtless soon die." Richard Eddy, army chaplain, dubiously wrote, "I have seen of its medicinal qualities in a pamphlet by a Rev. Mr. Stringfellow . . . his work opens with an exceedingly highfalutin description of original sin . . . passes to a detailed description of the cures performed by the Springs on some thirty or more patients, who, it would seem from his account, were afflicted with all 'the ills that flesh in heir to.' " (Photograph by Timothy H. O'Sullivan; Library of Congress.)

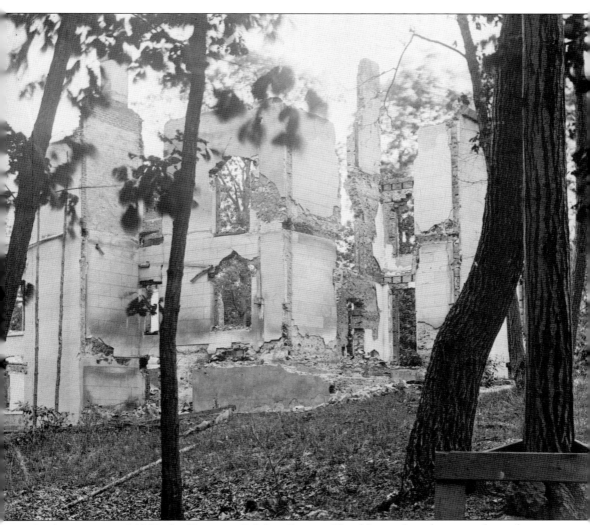

In the summer of 1862, the Fauquier Sulphur Springs Hotel burned to the ground, catching fire after a shell strike during skirmishes between General Pope and Stonewall Jackson, as they positioned themselves for the Battle of Second Manassas. There were skirmishes all along the Rappahannock River during which General Mosby was imprisoned but released. Mosby noticed Federal troops being sent to reinforce Pope. He notified General Lee in Richmond, and Jackson was sent to attack the Federals; Pope was subsequently defeated at Cedar Run. The convergence of Federal troops around the springs area, on their way to Manassas, eventually led to the destruction of the hotel on August 22. It is unknown which side was responsible for the strike. An article from the *Washington Capitol* in 1877 states, "Whether the fire was kindled by Jackson shooting at Pope or the hero of the saddle firing at the great Stonewall, is a question that will never be solved." (Photograph by Timothy H. O'Sullivan; Library of Congress.)

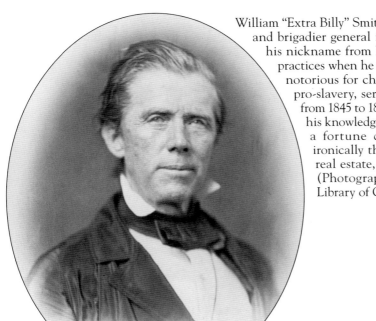

William "Extra Billy" Smith was a lawyer, politician, and brigadier general in Warrenton; he earned his nickname from his questionable business practices when he ran a mail service; he was notorious for charging extra fees. Smith, pro-slavery, served as Virginia governor from 1845 to 1849 but was elected without his knowledge! After his term, he made a fortune during the Gold Rush, ironically through practicing law and real estate, not by panning for gold. (Photograph by Julian Vannerson; Library of Congress.)

John Letcher, the 34th Virginia governor, appointed Extra Billy Smith as colonel of the 49th Virginia Volunteers, but not without hesitation. Extra Billy, aged 64, stated, "The Governor replied . . . that I was too old . . . I would like to see the young man who could stand more hardship and fatigue than I . . . [Letcher] said, if you insist upon it, I will not refuse . . . in the words of the bridegroom, when asked if he would take this woman as his wedded wife, 'zounds man, that is just what I come for.' " (Photograph by Julian Vannerson; Library of Congress.)

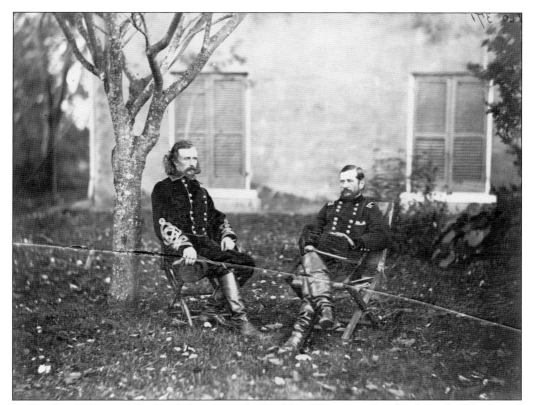

In October 1863, a cavalry battle known as the Buckland Races was fought along the Warrenton Turnpike. Confederate generals J.E.B. Stuart and Fitzhugh Lee successfully pushed back Federal forces commanded by Gen. George Custer. Lee lured the Federals toward Warrenton, ambushing them near Greenwich Road with his 5,200 hidden men. Two hundred prisoners, along with Custer's ambulances, medics, and personal papers, were sent to the Old Jail. Pictured are Custer (left) and General Pleasonton (right) at camp in Warrenton before their loss. (Photograph by Timothy H. O'Sullivan; Library of Congress.)

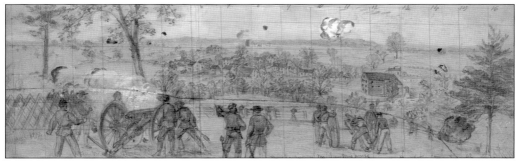

Alfred Waud captured a scene at the Buckland Races from a field behind Eppa Hunton's home, Brentmoor. Today, there is not much of a view behind Brentmoor due to development, but its hilltop location allowed for a clear account of the skirmish on the Warrenton Turnpike. Waud was instrumental as an eyewitness during the war—camera equipment was far too primitive for the battlefield. Often, Waud risked his life during combat, armed only with pencil and paper. (Library of Congress.)

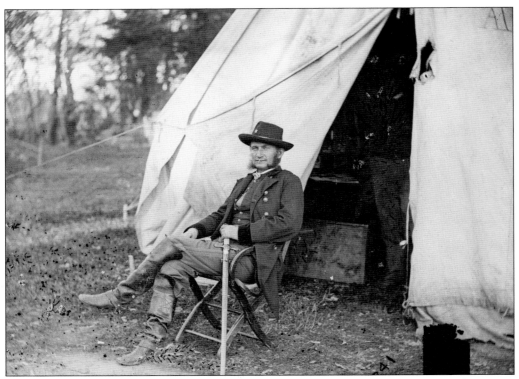

Gen. Judson Kilpatrick was one of the Union cavalry commanders who chased Stuart down the Warrenton Turnpike. Stuart's cavalry turned around and ambushed Kilpatrick's forces, chasing them back up the turnpike for five miles, initiating the Buckland Races before Custer's attack met its end. Here, in September 1863, General Kilpatrick poses for a picture in Warrenton. (Photograph by Timothy H. O'Sullivan; Library of Congress.)

Eppa Hunton was a political figure who resided in Warrenton. Before the war, he served as a delegate in favor of secession to the Virginia Secession Convention. He became colonel of the 8th Virginia Cavalry and brigade commander in the divisions of Generals Longstreet and Pickett. He was wounded during Pickett's Charge. After the war, he practiced law in Warrenton and became a congressman from 1873 to 1881. In 1894, he and his son were involved in a voting bribery scandal; they were exonerated. (Library of Congress.)

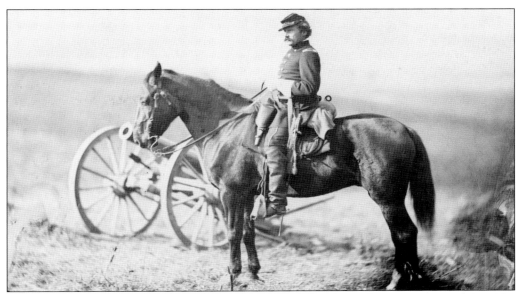

Pictured here in Warrenton around 1862, Albert V. Colburn began his career as a cavalry rider on frontier expeditions before being appointed second lieutenant in the 1st US Cavalry in 1856. After command during the First Battle of Bull Run, he was appointed assistant adjutant general to Gen. George McClellan. Colburn remained loyal to McClellan despite the general's dismissal by Lincoln. Colburn was assigned to General Schofield in Missouri but died six months after this appointment from illness at the age of 32. (Photograph by Alexander Gardner; Library of Congress.)

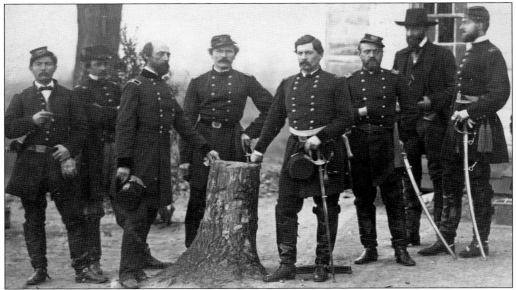

General McClellan gave a goodbye salute to his troops from the balcony of the Warren Green Hotel in Warrenton in 1862, when he was relieved of duty by President Lincoln. General Burnside, his respectful replacement, hand-delivered McClellan's dismissal letter to his headquarters in nearby Rectortown. McClellan and his staff are pictured here, including Assistant Adjutant General Colburn, in March 1862. (Library of Congress.)

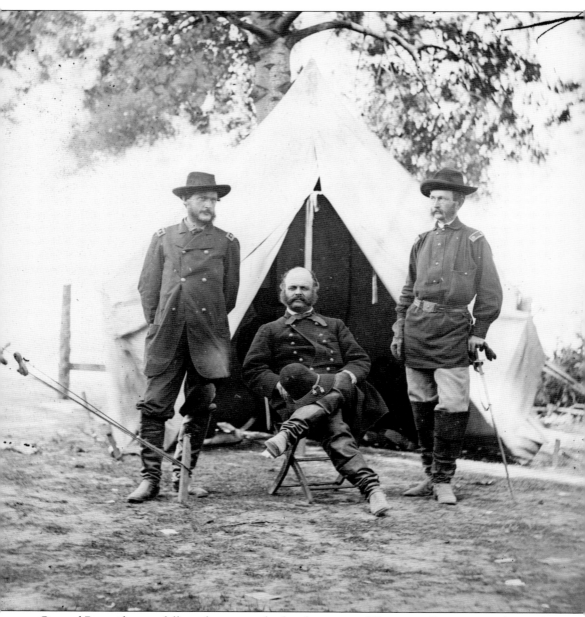

General Burnside gracefully took command at headquarters in Warrenton. Recognizing the men's loyalty to McClellan, he stated the following in his address: "Their feeling of respect and esteem for General McClellan, entertained through a long and most friendly association with him, I feel that it is not as a stranger that I assume their command." He ordered honors issued to McClellan as he took his leave. General Burnside (center) was camped in Warrenton in November 1862. Dr. Mary E. Walker, the only woman to ever receive the Medal of Honor, was appointed as Burnside's field surgeon. She treated many patients suffering from a typhoid fever outbreak in Warrenton in 1862. During her service, she often crossed enemy lines to treat patients and was arrested as a spy. After the war, she became a famous suffragette and was arrested several times for "impersonating a man." (Photograph by Alex Gardner; Library of Congress.)

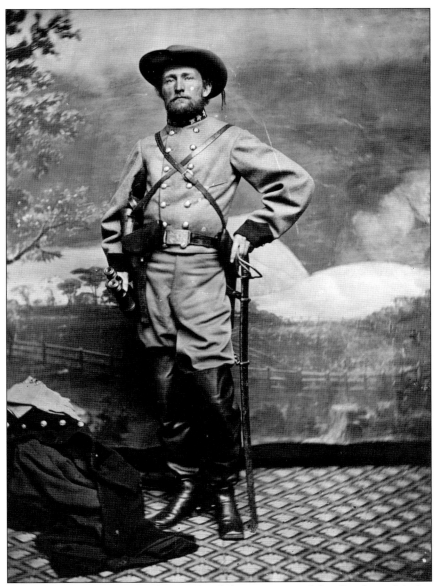

In 1863, Gen. J.E.B. Stuart gave orders to Confederate captain John Singleton Mosby to form Company A, 43rd Battalion of the Virginia Cavalry. This company would become known Mosby's Rangers, inflicting the most damaging guerrilla attacks on Union troops in the history of the war. Mosby himself would be called the Gray Ghost. Before the war, Mosby was imprisoned for shooting a man at the University of Virginia, where he was attending school. In jail, Mosby apprenticed under his prosecutor William J. Robertson, whom he had surprisingly befriended. He passed the bar and practiced law in Albemarle County after he was released. Warrenton was occupied by Union forces most of the war, despite the Rangers' determined attempts to drive them out. Mosby's Rangers were involved in many famous skirmishes around Warrenton, including action at Warrenton Junction, Brandy station, the Greenback raid, and the capture of Colonel Dulaney. Dulaney's own son enlisted with Mosby and participated in his father's capture. Pictured is Colonel Mosby between 1860 and 1865. (Library of Congress.)

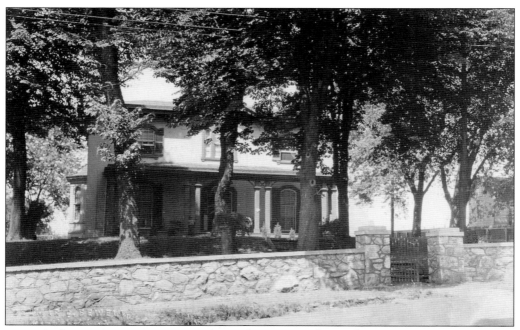

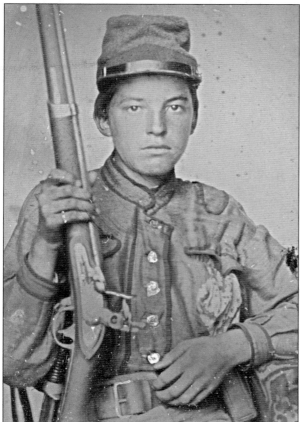

Located at 173 Main Street, Brentmoor was built around 1859 for Edward M. Spilman, who became a judge for the Fauquier County Circuit Court. It was sold to James Keith, president of the Virginia Court of Appeals, in the 1870s, then to Mosby in 1875, and to Eppa Hunton in 1877. Mosby sold the home while consumed by grief at the untimely deaths of his wife, Pauline, and infant son, Albert. It is now a museum dedicated to artifacts pertaining to the life and times of Col. John Mosby. (Anderson Collection.)

Mosby's Rangers were famous for their scattered assaults and effective methods of fighting, usually leaving Union forces devastated and baffled after being attacked. Sgt. William T. Biedler, shown in this c. 1860s photograph, is holding a flintlock musket; he was only 16 years old during his service to the Rangers. (Library of Congress.)

In 1863, Mosby and his Rangers crept to Fairfax Courthouse to capture a hungover Union general Stoughton. Mosby slapped him on the behind saying, "Get up, General, and come with me! Do you know who I am? Did you ever hear of Mosby? He has caught you!" That night, Mosby managed to capture 58 horses, two captains, and 30 prisoners without a shot; the bounty was brought to Warrenton, and Stoughton was held at the Fauquier Club townhouse. Pictured is General Stoughton, around 1860. (Library of Congress.)

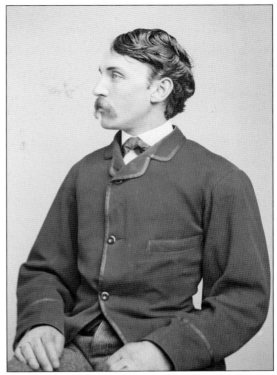

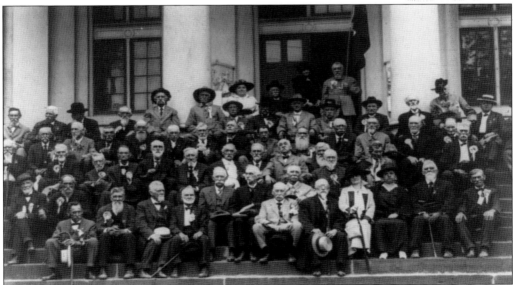

In his fiercely independent style, Mosby did not surrender officially at the end of the war; instead, he gathered his men in a field 11 miles outside of Warrenton and dismissed them himself. Mosby was the last Confederate to surrender. He returned to practice law in Warrenton and would later become a diplomat to China. Pictured are Mosby's Rangers gathered at a reunion on the Warrenton Courthouse steps around 1920. (Photograph by Underwood and Underwood; Library of Congress.)

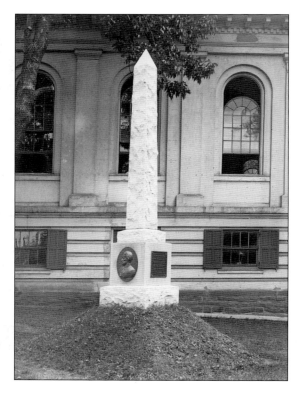

Three years after Mosby's death, the town campaigned for a monument in his honor. It was dedicated in 1920 in front of a large crowd, which included veterans of Mosby's Rangers. A poem about Mosby by Beverly Tucker was read, "And when the children gather 'round, Your knee at twilight hour, Tell them of Mosby and his men—of Southern knighthood's flower." This photograph was taken the year of the dedication. (Anderson Collection.)

This home was built in 1819 for US senator Inman Horner; Janet Weaver, granddaughter of Horner, was only 13 when she received word of a train full of wounded men bound for town. She tended to the dying men in this home. Pictured are the Inman and Weaver families and the 8th Pennsylvania Cavalry. Capt. Edward Carter purchased the house in 1907. Carter rebuilt it after the Great Fire of 1909. (Old Jail Museum.)

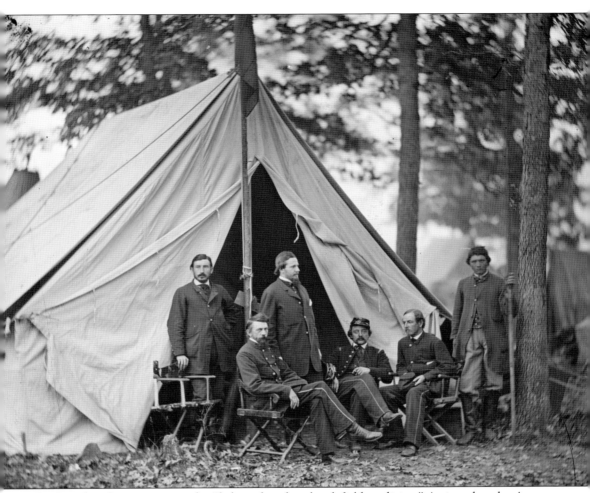

Dr. Jonathan Letterman was the "father of modern battlefield medicine." Assigned to the Army of the Potomac in 1861, Major Letterman's first Ambulance Corps changed the way wounded soldiers were handled after battle. Less than a year after his assignment, Letterman became medical director of the entire Army of the Potomac. After the Battle of Second Manassas, it took over a week to evacuate wounded men from the field. Many died alone, suffering where they fell, and this inspired McClellan to give Letterman full control over renovations of the army's medical procedures. Letterman developed an evacuation and triage system, as well as a supply distribution program; all were proven at the Battle of Antietam when 23,000 wounded men were evacuated in just 24 hours. In 1864, Congress officially adopted his system for the US Army. After the death of his wife in 1872, he died, suffering from grief. He is buried in Arlington National Cemetery. He is pictured here in Warrenton in 1862, seated on the far left. (Photograph by Alex Gardner; Library of Congress.)

A group of staff members from the Army of the Potomac poses in front of a tent in Warrenton, during the fall of 1862. From left to right are Col. N. H. Davis, assistant inspector general; Gen. John Buford, command of the 1st Division; Col. Delos B. Sasket, inspector general; Col. George D. Ruggles, adjutant general; and Col. H.F. Clark, commissary of subsistence. (Library of Congress.)

This 1862 photograph shows Union officers in Warrenton with their contraband servant, John Henry. Contraband servants were slaves who escaped from the South to serve the Union army. The photograph makes a joke at the servant's expense, since he is offering a jug of liquor to the captain "as the only appropriate prescription for the occasion that his untutored nature could suggest," according to Anthony W. Lee's *On Alexander Gardner's Photographic Sketch Book of the Civil War.* (Photograph by Alex Gardner; Library of Congress.)

Warrenton had a sad role in the result of the 1859 raid on the Confederate arsenal at Harper's Ferry by John Brown, a frustrated abolitionist who believed insurrection was the only path to end slavery. Brown's plan was to arm slaves, but his raid failed; two of his sons died in the conflict. The Black Horse Cavalry was sent to guard Brown while he awaited trial in a Charlestown, West Virginia, jail. This portrait of John Brown was created in 1859. (Photograph by Martin M. Lawrence; Library of Congress.)

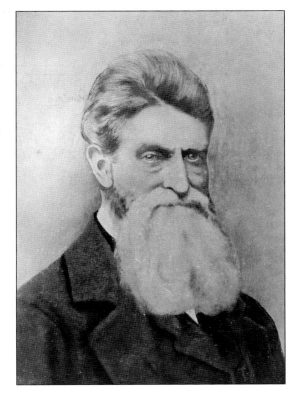

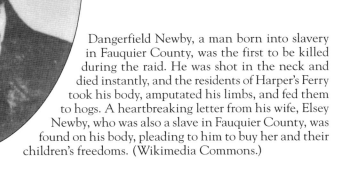

Dangerfield Newby, a man born into slavery in Fauquier County, was the first to be killed during the raid. He was shot in the neck and died instantly, and the residents of Harper's Ferry took his body, amputated his limbs, and fed them to hogs. A heartbreaking letter from his wife, Elsey Newby, who was also a slave in Fauquier County, was found on his body, pleading to him to buy her and their children's freedoms. (Wikimedia Commons.)

John Brown was hung for treason; one of his defense lawyers was Samuel Chilton from Warrenton, a slave owner. Chilton only represented him for the last two days of trial and was unsuccessful in obtaining an appeal for the guilty verdict. Stonewall Jackson provided an eyewitness account of the execution. In his description, he stated, "[He] behaved with unflinching firmness. Brown had his arms tied behind him, and ascended the scaffold with apparent cheerfulness. After reaching the top of the platform, he shook hands with several who were standing around him." As a result of the execution, the country moved closer to war, and Brown became an abolitionist martyr. This 1870 lithograph states, "Meeting a slave mother and her child . . . on his way to execution, regarding them with a look of compassion, Captain Brown stooped and kissed the child, then met his fate." John Wilkes Booth attended Brown's hanging. (Lithograph by Currier and Ives; Library of Congress.)

Lt. Col. Joseph H. Nelson joined Mosby's command in 1863. He was wounded in action at the Battle of Second Manassas and near Aldie, Virginia. During an attempt to rescue a fellow soldier, he was shot in the hip and was taken to recover in a hidden field hospital in the Bull Run Mountains. After the war, he became Warrenton's mayor for a term. His home at 171 Culpeper Street is pictured here in the late 19th century. (Old Jail Museum.)

The Black Horse veterans pose for a photograph in Warrenton at their reunion after the war. The reunion in 1890 took place at General Payne's home in Warrenton, as a rallying point in order to attend the unveiling of a monument dedicated to General Lee in Richmond. (Old Jail Museum.)

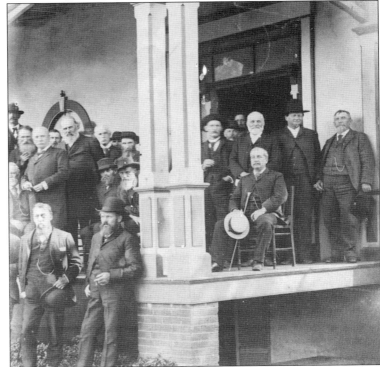

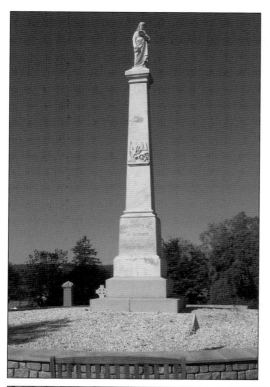

After the battles of First and Second Manassas, 600 fallen Confederate soldiers were buried in unmarked graves. Later, they were identified, and Warrenton schoolchildren made wooden markers for them. In 1863, Union soldiers, out of desperation during a brutal winter, burned the markers as firewood. The Ladies of the Memorial Association interred the bodies in the Warrenton Cemetery in 1877 in another unmarked grave, under the monument pictured. The names were thought to be lost forever. (Old Jail Museum.)

After a genealogical search in 1982 for a Confederate ancestor, Robert Smith of Illinois uncovered a lost box of records in the National Archives from the Warrenton field hospitals after a 14-year search. Subsequently, 520 of the soldiers were identified. The Black Horse Chapter of Warrenton raised funds for this granite memorial that encircles the existing monument, with names of the fallen engraved on it and room left for the soldiers yet to be identified. (Photograph by Kate Brenner.)

4, 1862

MCCARTNEY, A.J.
CO. B, 28 RGMT. OCT. 2, 1862

PRESTON,
CO. D, 28 R

1861

MERITT, JOHN B.
CO. B, 6 RGMT. SEPT. 20, 1862

RAMSEY,
CO. H, 12 R

862

NYE, JAMES J.
CO. D, 7 RGMT. SEPT. 8, 1862

RANSOM
CO. E, 9 R

52

PATRUM, WILLIAM A.
CO. E, 11 RGMT. SEPT. 4, 1862

RICHARD
CO. B, 42

162

PERKINS, THOMAS M.
CO. F, 38 RGMT. FEB. 27, 1862

SANGS
CO. A, 1

62

PERRY, WILLIAM H.
CO. I, 6 RGMT. SEPT. 21, 1862

SEMON
CO. D,

PIGG, HEZIKIAH H.
CO. D, 18 RGMT. SEPT. 25, 1862

SHELEF
CO. F,

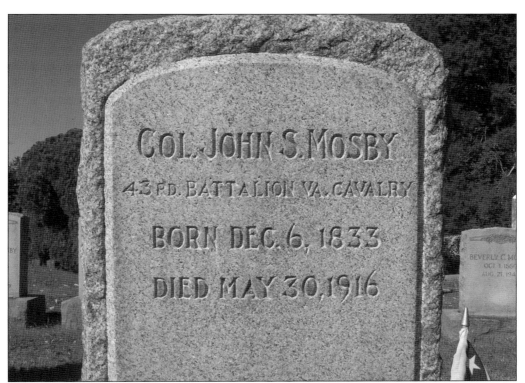

Many historical figures from the Civil War have made Warrenton their final resting place—Samuel Chilton, John Quincy Marr, and William Fitzhugh Payne are among them. John S. Mosby is one of the famous Confederates buried in the Warrenton Cemetery. Visitors can often find trinkets, flags, and mementos placed on his grave from his admirers. (Photograph by Kate Brenner.)

Gen. Fitzhugh Lee Payne is also buried in the Warrenton Cemetery. He was captain of the Black Horse Cavalry and was also second brigadier general under Capt. Fitz Lee. He was wounded and left on the field in Gettysburg but survived. His epitaph reads, "Not for empire nor renown, but for right and commonwealth." (Photograph by Kate Brenner.)

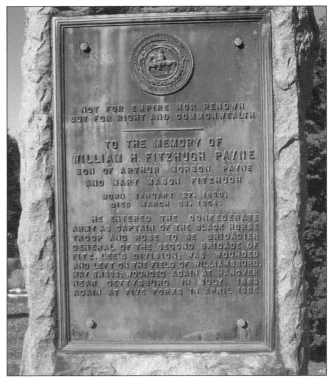

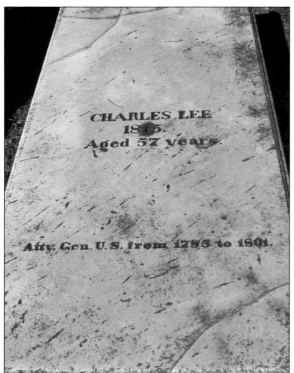

Charles Lee, US attorney general from 1795 to 1801, is buried under this ancient slab in the Warrenton Cemetery. (Photograph by Kate Brenner.)

Samuel Chilton, born in Fauquier County in 1805, was a prestigious lawyer and politician in Warrenton. He served in the US House of Representatives and as a Virginia delegate. Chilton was made to testify about suspicion surrounding who had paid his fees while he was John Brown's attorney. Chilton later declined an appointment in Lincoln's administration and returned to Warrenton. He was interred with Masonic honors in the Warrenton Cemetery. Pictured is the Norris-Chilton House at 50 Culpeper Street. (Photograph by Kate Brenner.)

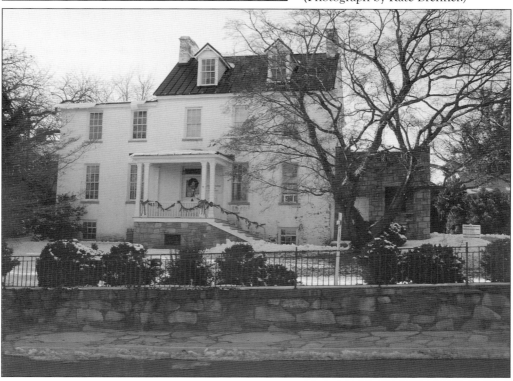

Three

CONSTRUCTION AND RECONSTRUCTION

Reconstruction in Warrenton after the Civil War meant the town's residents faced a dramatic economic and social change with the abolishment of slavery on top of the hardships of a war-torn county. Freed blacks began their integration into society by forming worship groups and building schools, though not without scorn and violence from angry whites, bitter from the outcome of the war. A Freedman's Bureau was established in Warrenton in 1865; one of its missions was to educate freed blacks in order to make them self-sustaining under the new order. One of these first schools in Warrenton, the Whittier School, received threatening letters and later a barrage of stones was pelted at the windows. A freed black man was arrested and placed in the Old Jail in 1880 for miscegenation and was dragged from his cell in the middle of the night and lynched in the cemetery. Klu Klux Klan activity was well documented in the darker corners of town. Though Warrenton did not see action during the war, the massive troop movement in the area resulted in the destruction of many important structures, including bridges, railways, and the famous Fauquier Sulphur Springs Hotel. At the turn of the century, just as Warrenton once again bloomed with prosperity, a devastating fire almost wiped out the entire town. Before that, a record snowfall stalled production and chilled the homes of Warrenton residents. Despite these difficulties, Warrenton did not crumble in the face of adversity; the town was destined to become a political and cultural center once again. The advent of the elite foxhunters and steeplechase races, along with the presence of distinguished political figures such as Chief Justice John Marshall and several US presidential visits, would all take part in restoring Warrenton to glory and success.

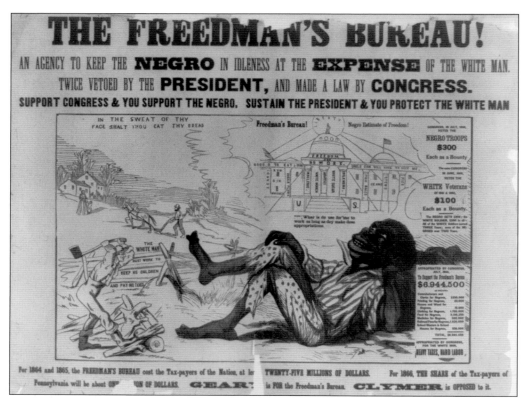

Fewer than half of the freed blacks were literate, and some struggled to support themselves in their new society. The Freedman's Bureau was created to provide aid; its Fauquier County headquarters was in Warrenton. Bitter whites often ridiculed it. This 1866 poster reveals the racism by stating the following: "The Freedman's Bureau! An agency to keep the Negro in idleness at the expense of the white man." (Library of Congress.)

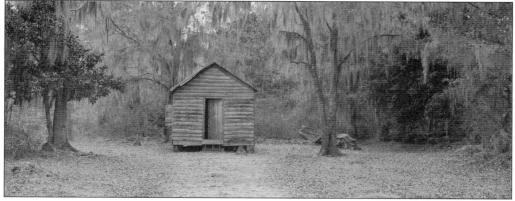

Fannie Wood, a Massachusetts Quaker, opened a school for blacks in Warrenton called the Whittier School. Upon her arrival, she received a letter from "Negroeville" stating that "the young men of this town think you are a disgrace to decent society and therefore wish you to leave this town . . . if you do not there will be violence used to make you comply to this request." A 1938 photograph shows the remains of a "negro schoolhouse" much like Whittier. (Photograph by Marion Post Wolcott; Library of Congress.)

Double Poplars was one of the few postwar free black settlements in Fauquier County. Most of the buildings have fallen to ruin, but the Poplar Forks Church and cemetery remain. Before the war, Virginia law forbade blacks from gathering to worship without a white minister present. They gathered secretly, just as they did under the two poplar trees at this site. After the war, the community purchased the land and later built a school. (Photograph by Kate Brenner.)

Pictured is the residence of Judge Semmes, also known as the Francis Carter Ritter house, built in 1850. A black servant stands with white children in front; often, black women were the maternal figures to white children, and both had to face losing each other. Myra Semmes recalls her "old mammy, a privileged character in the household, as she goes about still exerting that familiar maternal sway which . . . tenderly bound the women of the South to their dear old negro mammies." (Old Jail Museum.)

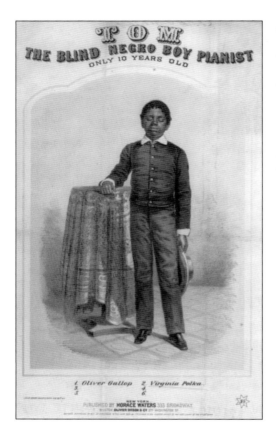

Thomas Wiggins Greene was born in 1849 into slavery; he was blind and autistic but had a remarkable musical ability. He was a composer by age six and publicly performing by age eight. His masters John and Eliza Bethune recognized the lucrative potential and hired him out as a "slave musician," made to play Confederate ballads. The Bethunes and Greene lived at Elway Farm in Warrenton for a few summers. He is pictured here at 10 years old. (Lithograph by Sarony, Major and Knapp; Library of Congress.)

Eliza Bethune, posing as Tom Greene's manager, exploited him; he was subjected to grueling travel and tours until he died on June 13, 1908. After emancipation, his mother, Charity Wiggins, died in poverty after many failed attempts to be in Tom's life. The Bethunes had made over $50,000 a year off Tom's talents. Even this 1880 photograph of Tom included a copyright by John Bethune. (Library of Congress.)

Freed slaves in a black settlement named Blackwell town, after the Blackwell family who freed them, built the Ebenezer Baptist Church. It was the first postwar black church in Fauquier County. It was founded by Henely Chapman, a freed slave who obtained permission in 1866 from Millie Blackwell to have a prayer meeting in her home, which was formerly owned by her mistress, Elizabeth Blackwell. (Ebenezer Baptist Church.)

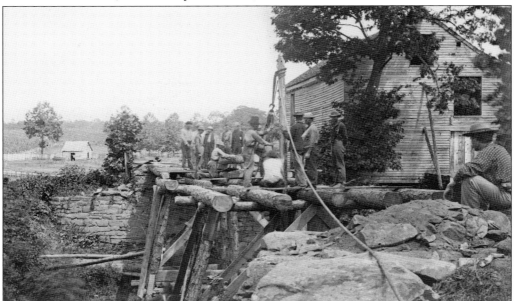

Warrenton was one of the most devastated areas in Fauquier County after the war. Fields, buildings, roads, and rail lines had been destroyed; the citizens faced an uphill battle in restoring their infrastructure. In this photograph, men try to restore one of the destroyed bridges over the Rappahannock River after the Second Battle of Bull Run in 1862; nearby are the ruins of the Fauquier Sulphur Springs Hotel. (Photograph by Timothy O'Sullivan; Library of Congress.)

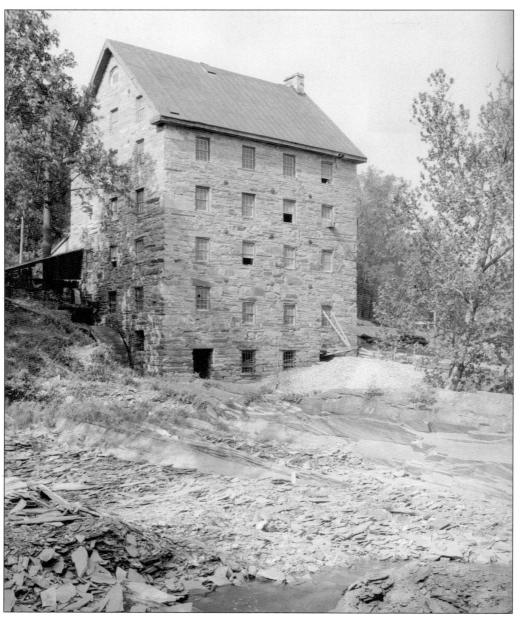

The destruction and loss of property plagued Fauquier County's citizens. Confederate soldiers, in an effort to keep Union soldiers from exploiting it, burned Chapman's (Beverley's) Mill at Thoroughfare Gap in 1861. Often, the structure was used as a sniper point; it was one of the tallest buildings in the area. Its owner John Chapman witnessed the destruction of the glorious mill he had built with his son and sued the government for damages—to no avail. His business floundered, and he suffered a nervous breakdown in 1862. His family committed him to an insane asylum, and he died four years later. The mill is pictured here in 1933, after some restoration. The mill continued to operate until 1951, but in 1998, arson once again claimed the beautiful structure. It is currently being restored and is visible off Interstate 66 between Haymarket and The Plains. (Historic American Buildings Survey, Library of Congress.)

Shortly after the war, Maj. Albert G. Smith, a member of the Warrenton Rifles under John Quincy Marr, founded the Bethel Military Academy in 1867. The first school building was a renovated log house, but the academy quickly expanded. It operated until 1911 and was an important symbol of rejuvenation in Warrenton. No other institution was as widely known as Bethel Military Academy during that time. Pictured is a young cadet named VanClief Ricker, in full dress uniform at the academy. (Old Jail Museum.)

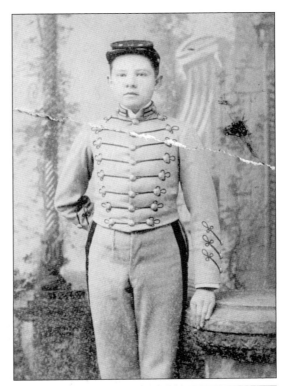

The curriculum followed a military-style approach. Each year after 1900, the second Friday in May was designated Founder's Day, and cadets participated in team and individual athletic contests. Organized recreation, such as football, was popular at Bethel Military Academy; pictured here are members of the Bethel football team. They competed against other academies from Warrenton and surrounding Fauquier County. (Old Jail Museum.)

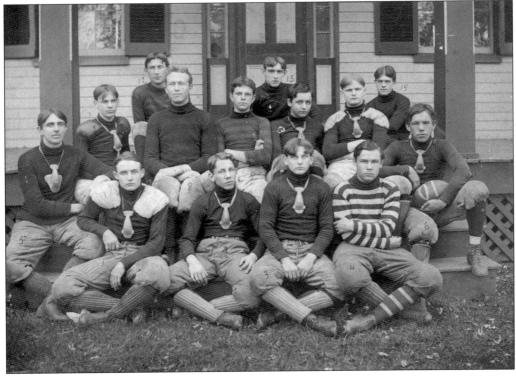

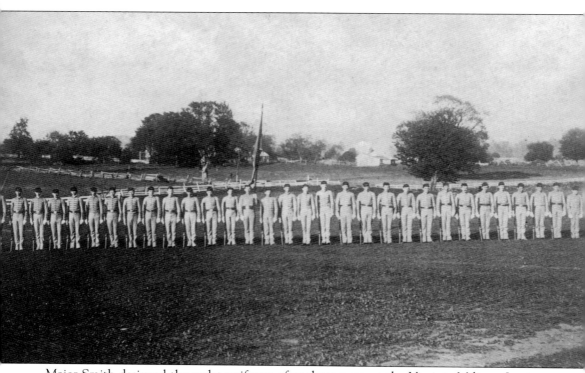

Major Smith designed the cadet uniforms after those worn at the Virginia Military Institute, modeled here by cadets in full uniform. These uniforms costs the students $17 a set, and fatigue uniforms were $16 per set. Their manual read, "No man looks noble unless there be something of the Military in his carriage and the slovenly swagger of neglected youth too often settles a bent and crooked figure on one who would otherwise be a noble specimen of manhood." In 1902, a cavalry corps was formed; cadets in the cavalry department wore government-issued uniforms of campaign hat and leggings, which cost the rider $12. After Smith's death in 1892, a new site was planned at the Fauquier Springs Resort property. Enrollment did not keep time with the costs of the new property, and the school was relocated to its original site. At the turn of the 20th century, the school was forced to close. Only the Bethel Methodist Church remains, which is still in use today. (Old Jail Museum.)

John Robert Spilman built the Warrenton Baptist Church in 1866. The Odd Fellows Building at 109 Main Street was used as the Baptist meeting hall, and a Civil War hospital was within its walls at one point. Rev. Robert Ruffin was pastor at the First Baptist Church and was instrumental in building the current Baptist church in 1890 on Alexandria Pike. He is buried in the Warrenton Cemetery. (Anderson Collection.)

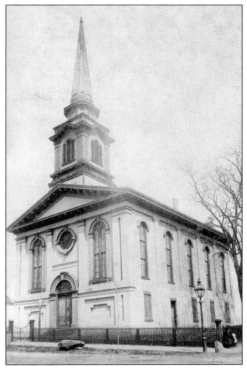

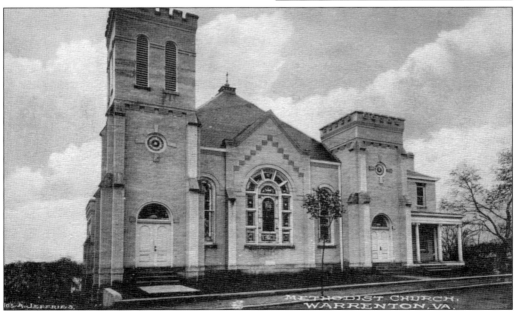

The Methodist church was originally in the old town hall at the corner of Fourth and Main Streets in 1854, but this property was sold to used as a town hall and, later, a firehouse. Built in 1911, the Methodist church at 44 Winchester Street is a rare example of Romanesque Revival architecture and boasts huge stained-glass windows. The Hanbacks, who also built the Episcopal church, constructed it. (Anderson Collection.)

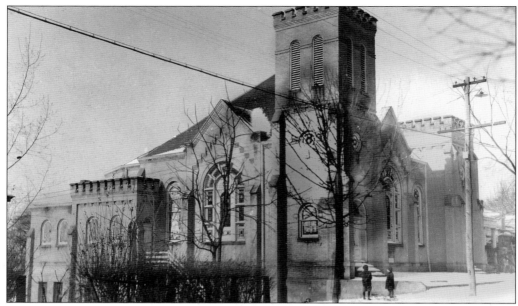

In 1816, the first Episcopal church within town limits was St. James Church, built just below the courthouse. In 1853, a new brick church at 81 Culpeper Street was constructed; it continues today as the site of St. James Episcopal Church. This congregation has its origins with the 18th-century settlement at Elk Run, now the site of an extensive archaeological dig. Shown is the current site of the church, photographed in the early 20th century. (Anderson Collection.)

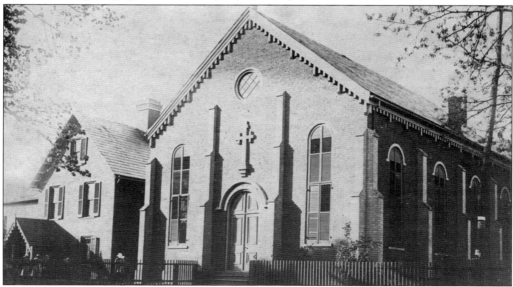

The original St. John the Evangelist Church was dedicated in 1861 in Warrenton as a mission of Sacred Heart Cathedral in Richmond. The difficulty of travel between the towns made for infrequent visits from priests, so a rectory was built in 1872, and Fr. Jim Dougherty was the first resident. By the mid-20th century, Warrenton experienced post–World War II growth much like the rest of the nation. St. John expanded into a new church and school in 1960. Pictured is the old portion of the church in the 1940s. (Anderson Collection.)

The Presbyterians and Episcopalians worshipped together initially, but the Episcopalians bought out to build their own church. The Presbyterian church was organized in 1780, and the original brick church was built in 1813 but was destroyed by a tornado in 1849. Rebuilt in 1855, it was then damaged by Federal troops who burned the pews and cut a hole in the floor to throw hay to their horses, stabled in the basement. (Anderson Collection.)

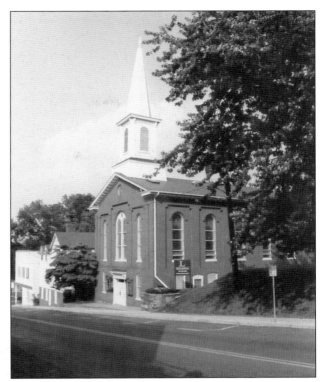

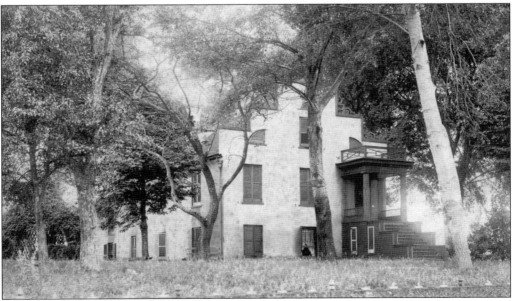

Extra Billy Smith built Monte Rosa, off Culpeper Street, in 1841, pictured here in 1885. Now known as Neptune Lodge, it has lost its exotic Italianate architecture and no longer resembles this picture. A fire in 1921 severely damaged the inside of the home, further changing its original form. James Maddux purchased it in 1895 and named it after one of his racehorses. Maddux was one of the few horseman to recognize the potential of the great horse Man o' War. (Old Jail Museum.)

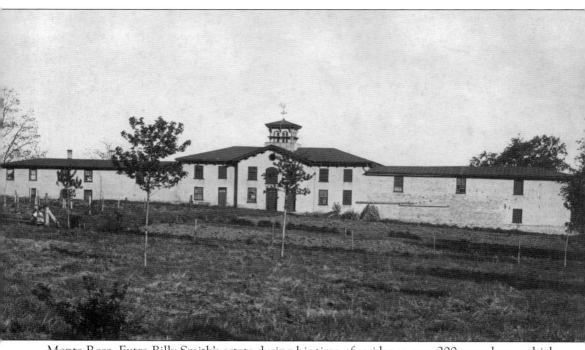

Monte Rosa, Extra Billy Smith's estate during his time of residence, was 200 acres large, which included the stables, pictured here during the 1880s. The grand, two-story stables were probably added around 1856 or 1857. Chimneys still stand on one wing of the stables, indicating there once were dwellings for farmhands. Before the construction of the grand stables, smaller stables existed on the site and were used as a stopover for the mail and stage line between Washington, DC, and Milledgeville, Georgia. James Maddux, a prominent Thoroughbred breeder and cofounder of the Warrenton Hunt, significantly changed the style and architecture from Italianate to the Colonial Revival style seen today. Maddux also changed the name from Monte Rosa to Neptune Lodge, in honor of his favorite horse. The famous Warrenton Horse Show was held in close proximity to the Neptune Lodge Stables, practically in its backyard. (Old Jail Museum.)

Built in 1889 by Albert Fletcher, the Fletcher's store is shown here in the late 1800s, located at Third and Beckham Streets. Albert Fletcher was a member of the Warrenton Rifles, serving as quartermaster sergeant, and also contributed to modifications of the rebuilt courthouse in 1890. He represented Loudoun and Fauquier Counties as a Democrat at the Virginia Constitutional Convention. (Old Jail Museum.)

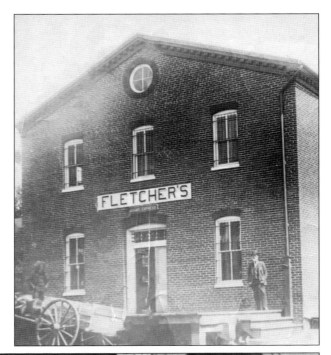

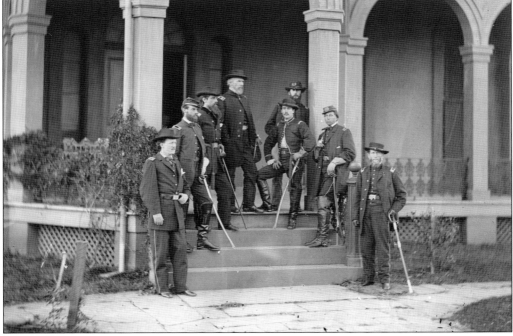

Union generals McDowell, Sumner, and Russell used this home as Civil War headquarters when Warrenton changed hands to Union occupation during the war; it also served as a hospital during the Battles of First and Second Manassas. Back then, it was a brand new home; the Italianate mansion was built in 1859 for Rice W. Payne. Virginia Payne was known for her entertaining talents, providing warmth and dancing to many guest Confederate soldiers. (Old Jail Museum.)

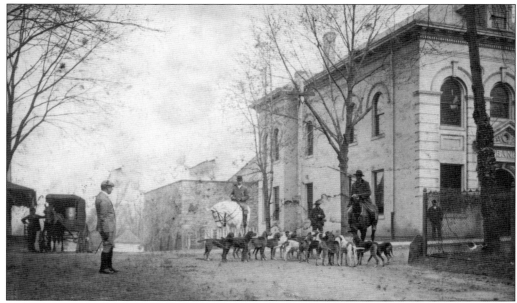

When Extra Billy Smith returned from reinventing his fortune out West, he named this structure the California Building. John Mosby and Eppa Hunton both used this building to practice law after the war, and it remains home to offices today. Here, in front of the California Building, hounds stand at attention to the foxhunters who commanded them in the early 1900s. The rounded base of the building was to protect the fence from being clipped by carriages. (Old Jail Museum.)

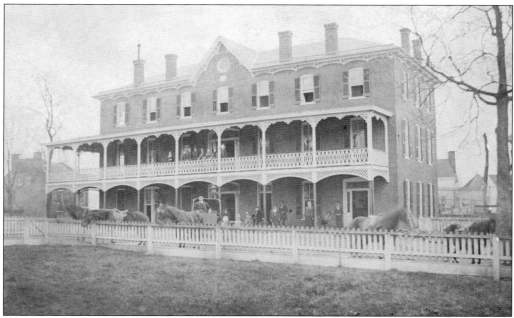

This hotel, built on the site of the Norris Tavern, was a tiny "ordinary" that served humble travelers in the early 1800s but would become the catalyst for the growth of Warrenton. The French general Marquis de Lafayette visited the tavern in 1825 during his post–Revolutionary War tour. The Warren Green Hotel was sometimes referred to as Eagle's Nest. (Old Jail Museum.)

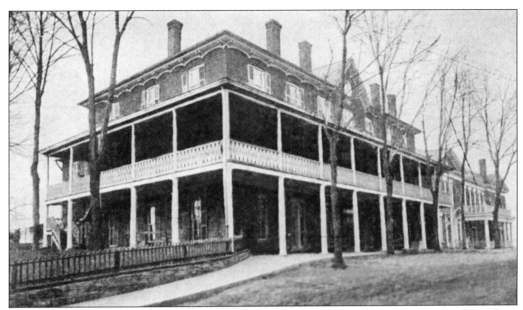

For a period, the Warren Green Academy, run by R.M. Smith, was housed in the hotel building. In 1850, the academy closed, and the Warren Green Hotel was born when J. Beckham purchased it; just 12 years later, the hotel was destroyed in a fire. George B. Cochran rebuilt it in 1876, and then Caroline Ullman purchased it in 1897 for $10,000. Pres. Andrew Jackson used the tavern as a stopover en route to Washington, DC, as did Henry Clay. (Anderson Collection.)

On a wager that he could make the ride and return by dinnertime, Teddy Roosevelt rode from Washington, DC, to the Warren Green Hotel. He had lunch there and won the wager with his speedy return. His purpose was to set the standard for US Army riders' endurance; he successfully rode over 100 miles in one day. Shown is Roosevelt, on left, demonstrating his riding abilities in 1907. (Library of Congress.)

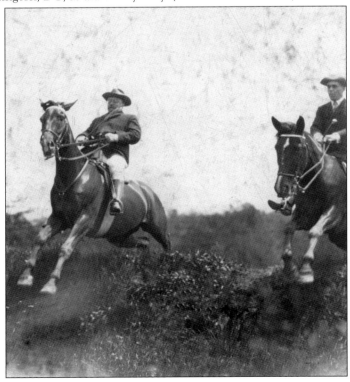

Pictured here is the Charrington House, which is no longer in existence. Dr. John Wise, a retired Navy physician and close friend of Teddy Roosevelt, lived here when Roosevelt came to Warrenton. He introduced the president to many excited residents, and even the schools let out early that cold day to honor Roosevelt's visit. The president graced the town with a large painting of himself and a personalized inscription, which is on display in the Virginiana Room at the Warrenton Library today. Lt. Col. Gerald Keith Matchett of the British Connaught Rangers and Mary Randolph Charrington, who were married, lived in this home called Waverly at the end of the 19th century. The Randolph family was particularly prominent in Virginia, having many important political descendants, including Thomas Jefferson and president of the First Continental Congress, Peyton Randolph. Legend tells that Pocahontas was related to the family through marriages as was Davy Crockett. (Old Jail Museum.)

Fauquier Springs Resort was a popular destination during the 1830s, due to the hot sulfur springs' healing properties. Located on the property were 16 cottages and a large hotel that stood four stories high with a 4,000-square-foot ballroom. Notable guests include Chief Justice John Marshall and US presidents James Monroe, James Madison, and Martin Van Buren. Pictured is the resort at the end of the 19th century. (Old Jail Museum.)

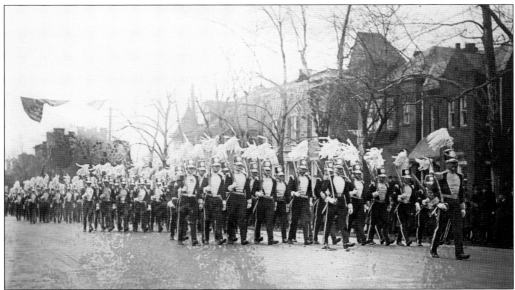

The Richmond Blues, a volunteer militia, served during the Civil War as Company A, 46th Regiment, Virginia Infantry. They rejoined the 1st Virginia Regiment after the war and spent summers camped at the springs. Upscale balls were given in their honor at the resort, after it was rebuilt. They were known for their service and their social events, often participating in parades and celebrations. The Richmond Blues are shown here in 1923, celebrating Washington's Birthday in Alexandria, Virginia. (Harris and Ewing, Library of Congress.)

In 1849, the Virginia Legislature moved its operations to the springs in fear of a cholera outbreak in Richmond. Chief Justice Roger B. Taney wrote the Dred Scott Decision at the springs during the summer of 1856. (Old Jail Museum.)

The Brent family sent four sons to serve during the Civil War in Mosby's Rangers and Turner Ashby's Mountain Rangers. William Brent recorded the atrocities of war in a gripping diary account, including the death of his brother. The Brents occupied Brenton, in The Plains, until around 1930. Pictured is Brenton, long before the front porch was removed, in 1890. (Old Jail Museum.)

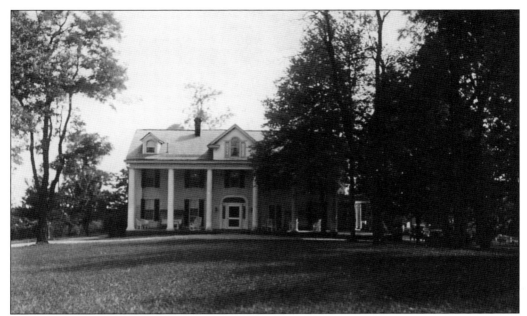

John Quincy Marr built this home in 1855 for his mother, sisters, and himself. He would not be able to watch his family grow here; he was killed just six years later on June 1, 1861, at the Battle of Fairfax Courthouse. (Anderson Collection.)

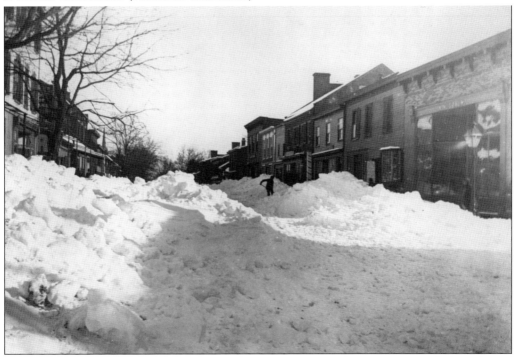

The "Great Arctic Outbreak of 1899" struck Warrenton on Valentine's Day with 54 inches of snow. The 1898–1899 winter was so cold over a large part of the United States that ice flowed from the Mississippi River into the Gulf of Mexico. (Old Jail Museum.)

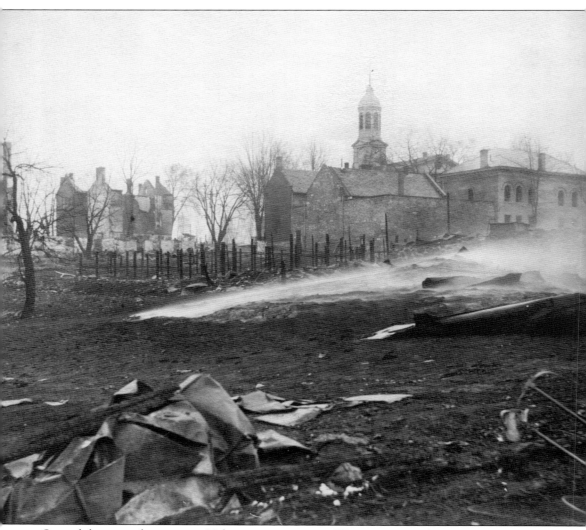

One of the most devastating 20th-century events in Warrenton was the Great Fire of 1909. Presumably started by a barn fire, it almost destroyed the town. It was halted by a heroic dynamiter C.C. Waugh, who ignited a 50-pound box of dynamite in the fire's path with just a rolled piece of paper. The *Baltimore Sun* reported that Waugh "unhesitatingly wrapped a bunch of newspapers tightly in his fingers and set a match to them. Glancing at the open cellar door and gauging the distance, he leaned over cat-like and threw the blazing paper at the dynamite. He figured that it would take several seconds for the flames to eat inside the pasteboard and he took a chance that those two seconds would give him his life." During this time, the fire equipment was stored under the courthouse porch, and luckily the volunteer firefighters were nearby as they were waiting for their mail when they heard the courthouse bell ring in alarm. (Old Jail Museum.)

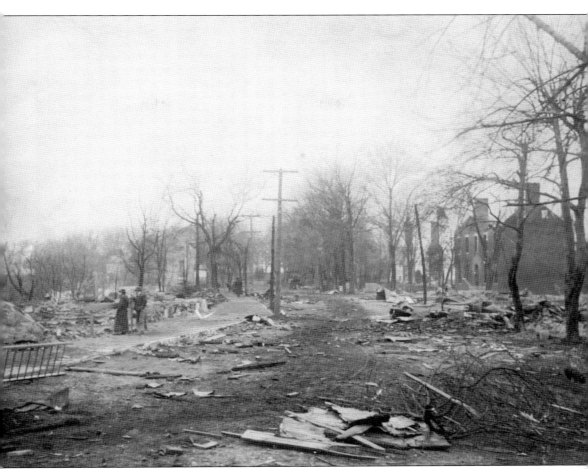

According to the *Baltimore Sun*'s reports, "26 buildings were burned to the ground, 14 families left homeless, several of them destitute; nine buildings were rent to kindlings to prevent the spread of the blaze, the municipal building is gone, the town library destroyed, some of the finest residences are burned and with them heirlooms of priceless value to the owners, and several townsmen were ruined financially. The entire western part of the town is gone." Despite the best efforts of the Bethel Cadets, Carter Hall was left in ruins, but it was later rebuilt. Many historic buildings have been lost to fire throughout the United States mostly due to a lack of preventative systems. One of the first purchases made by the fire department in 1852 was "three dozen fire buckets." The following year, eight men were hired at $1 per night to patrol the town after sunset. The fire probably blasted out of control because of a drought that year; the tapped reservoir barely had pressure to run the water down the fire hose. The town had not yet purchased its first fire engine but would do so shortly after the disaster. (Old Jail Museum.)

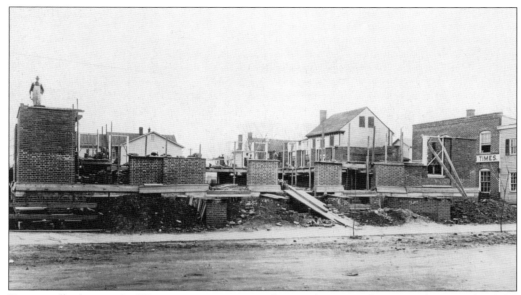

Despite all of its trials, Warrenton was growing fast, as shown in this 1920 photograph of the town. That year, the town had even purchased its first motor-driven firefighting equipment—a Chevrolet truck with a 50-gallon chemical tank. Firefighting methods were still antiquated. The courthouse bell served as the alarm and whoever heard it would start the truck and help unreel the hose, if they could get it up or down the hill. In 1924, the town purchased a steam whistle. (John Gott Library.)

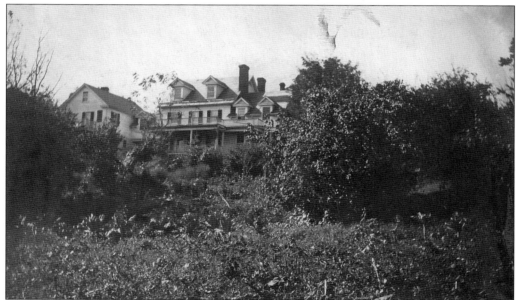

Britton Hall was built in 1790 for William Horner, an attorney in Warrenton. His son Dr. William Horner was a surgeon and anatomy professor at the University of Pennsylvania. He wrote the first American textbook on pathology. Britton Hall also served as a boardinghouse after the war. It is located at 45 Winchester Street. This photograph shows Britton Hall in 1920. (Bob Lawrence Collection.)

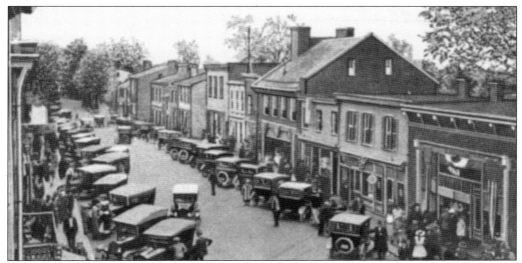

The Masonic Building at 7–11 Culpeper Street was the first and only structure in Old Town to get an elevator. Technology did not always bring the best elements to town, and parking became an issue as the commercial section of Warrenton grew. Many historic buildings were lost in order to make parking lots before Warrenton earned historic designation. Shown are a number of Model-Ts crammed on Main Street. (Anderson Collection.)

In 1914, Lea Bouligney established the Warrenton Country School for Girls just off Spring Road in Warrenton, which served around 100 young ladies each session until 1948. A 1922 advertisement for the school in the *Current History*, a publication by the *New York Times*, reads, "French the language of the house; teaches girls how to study, no extras." Bouligney was the principal of the Chevy Chase Seminary at the Chevy Chase Inn in Washington, DC. (Library of Congress.)

Bouligney's Warrenton Country School for Girls was purchased by the US government and transformed into the mysterious Warrenton Training Center (WTC). It is a classified communications training and support facility of the National Communications System (NCS). The US Army oversees the WTC on behalf of the NCS. The Warrenton Training Center was first established in June 1951 and is still under heavy security and operating today. Pictured is the entrance over half a century ago. (Anderson Collection.)

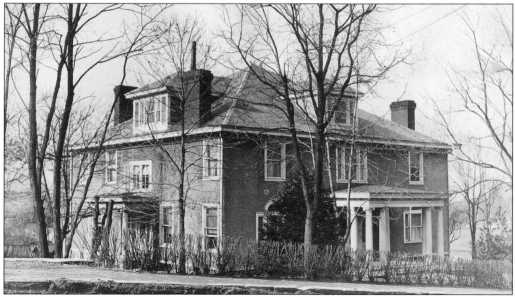

Founded in 1925, the first hospital in Fauquier County was located in a residence at 32 Waterloo Street. The Garner House was purchased for $14,000 from Frances Garner Grayson in 1924. There were 184 operations, 57 emergency treatments, and 22 babies delivered that first year. As a small nonprofit hospital, it closed in 1940 for lack of support. In 1958, the current hospital on Hospital Hill was opened. (Anderson Collection.)

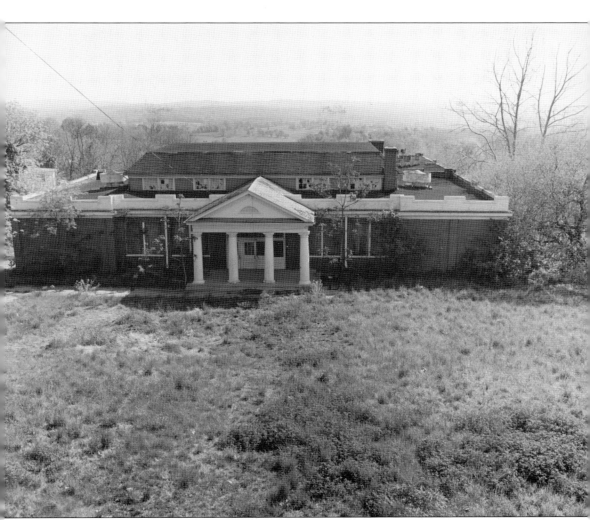

The academy movement brought many expensive, upscale, and well-respected schools to Warrenton. However, public schools were necessary to accommodate the growing population in town. Fauquier High School, one of the three high schools in Fauquier County, opened in 1963. Warrenton Middle School first opened in September 1936 as Warrenton High School, pictured in this photograph. In 1963, when Fauquier High School opened, the last senior class graduated from Warrenton High School. These schools were all segregated; integration did not come to Fauquier County until 1979. W.C. Taylor High School, the county's school for African Americans, was opened in 1952. The *Fauquier Democrat* described it as "a model of its kind. Without unnecessary frills, it still contains every modern feature that the latest in school design can incorporate." (Old Jail Museum.)

The Fauquier National Bank of Warrenton was opened in 1902 and still exists today as the Fauquier Bank. Built at the cost of $69,850, it was originally located behind the Juvenile and Domestic Court Building; the bank moved to Courthouse Square in 1972, and the structure was donated to the town. (Anderson Collection.)

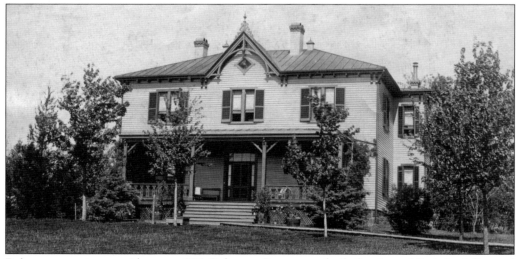

Balcarres, a private residence at 386 Culpeper Street, was built for sisters Virginia, Julia, and Victoria Lomax in 1875. The Lomax sisters operated their school for girls called the Warrenton Seminary for many years. Architect William Lawrence Bottomley upgraded it in 1929. Col. Robert Deans, a former commanding officer at the mysterious Warrenton Training Center, was a reported guest here in the 1960s after the seminary had closed and Balcarres became a private residence. (Old Jail Museum.)

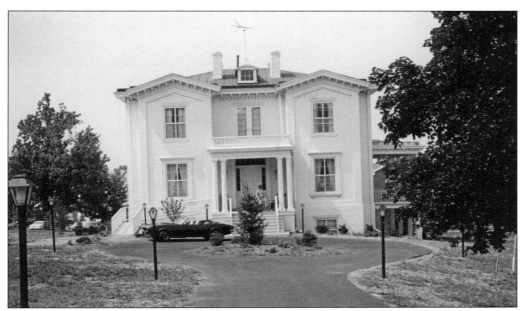

Opened in 1857, the Fauquier Female Seminary at 194 Lee Street was a boarding school where wealthy families would send their daughters for distinguished lessons expected of the female upper class, such as foreign languages and music. One of its boarders was Gen. Douglas MacArthur. He stayed in the late 1880s as a young child while visiting his aunt, Emily M. Fair, nearby at 139 Culpeper Street. (Old Jail Museum.)

Pictured is the lobby of the post office in town. It was built in 1916 and is a prime example of Colonial Revival architecture and a keystone part of the town. It was almost moved for lack of parking until a generous Warrenton resident donated the land behind it to provide more parking and room for mail trucks. (John Gott Library.)

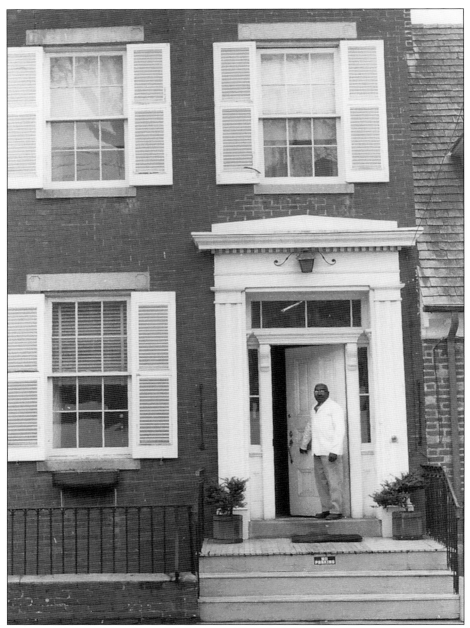

The Fauquier Club, or "Gentleman's Library and Social Club," opened in a townhouse called the Beckham House at 37 Culpeper Street when it was officially chartered in 1920, though it had existed since 1874. Mosby brought General Stoughton here for an evening of rest after his famous yet embarrassing capture in Fairfax County. James Maddux signed an affidavit, witnessed at the Fauquier Club, that negated claims by Sam Riddle who said that he had first spotted the potential in the great colt Man o' War. Maddux stated, "Last in line came a great big upstanding chestnut colt . . . That's the best colt I've ever seen at Saratoga, not excepting any." And claimed that Riddle poked fun at him, saying in reproach, "He should ask him to bid on a colt that needed a crutch." Pictured here is custodian of the club, Robert Turner, in 1963. (Bob Lawrence Collection.)

Four

Bookies, Bridles, and Brushes

The beautiful, wooded rolling landscape of Fauquier County was a lure to paradise for foxhunters, horse racing enthusiasts, and horse breeders from all over the region. When the Warrenton Hunt was established in 1887, a new elite social element was added to the reputation of the town. The Casanova Hunt was organized nearby in 1909 by "foxhunting farmers," which gave new participation for farmers besides simply the use of their land. Scarlet hunting coats (referred to as "pinks") and silver service became the associated themes of the equestrian element, thus contributing to the status of Warrenton. Gen. George Patton was a foxhunter, and even Jackie Kennedy could be seen galloping the Fauquier County hunt territories before her husband's assassination. During the Great Depression and the world wars, foxhunting would grind to a halt but would be revived in step with the town's own recovery. In 1899, a few horsemen organized the Warrenton Horse Show in historic Neptune Lodge's field until they purchased their current plot in 1900, just a year later. Today, the Warrenton Horse Show still runs annually in the same location, although the town has grown up around it. In 1922, the Virginia Gold Cup was organized in a gentleman's club in Warrenton and would go from a few hundred spectators to over 50,000 today. Since the days of Lord Fairfax and George Washington, the "sport of kings" has been shaping and influencing the state of Virginia, now boasting eight different hunts in a 20-mile radius.

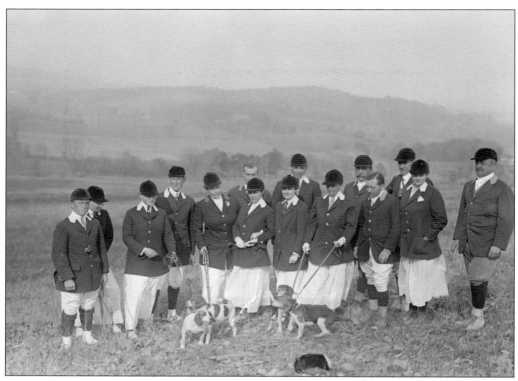

Warrenton became a destination for horse lovers across the disciplines, boosting the economy and tourism. It still has a deep presence in the equestrian community today. The Piedmont Hunt is pictured here in 1914 with its prized beagles against a backdrop of beautiful hunt country. Beaglers followed their dogs on foot, in chase of hares, rabbits, and the occasional fox. (Photograph by Harris and Ewing; Library of Congress.)

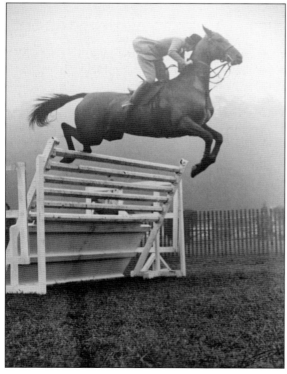

Foxhunting was the predecessor to most equestrian-related features in Northern Virginia. There are records indicating that, at least on one occasion, when a hunt coursed past the White House, the earliest politicians placed matters of policy on the back burner because the politicians interrupted the proceedings to mount their horses and join the chase. (Library of Congress.)

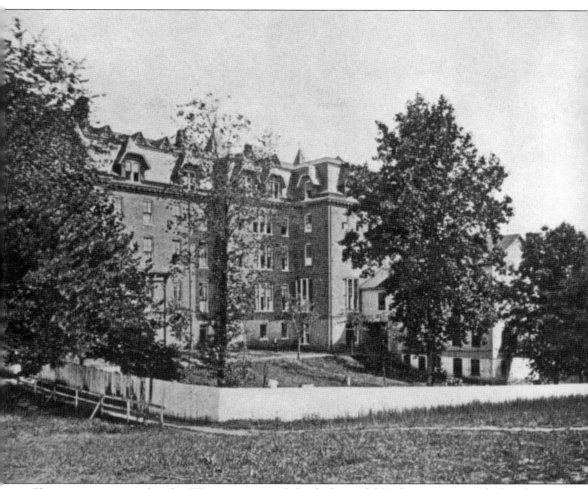

Elite equestrians were lured to Warrenton not only by the beautiful Piedmont countryside, but also by upscale facilities like the Fauquier Springs Resort and the Warren Green Hotel. These locales were used by socialites and politicians alike for recreation and relaxation and were considered some of the best in the metro area. Horse racing, medieval-style jousting tournaments, and foxhunting were all recreational events provided by the resort to equestrians. A Warrenton newspaper, *The Solid South,* reported on a steeplechase at the resort in 1875, describing it as "the best steeplechase ever run in America." At the finish line, the author described the spectators vividly. "The air was rent with the defining cheers that seemed to peal like drunken shouts from the multitude. There was not one who did not know that he won it by the hardest, most dashing ride ever performed in the country." Pictured is the back of the Fauquier Springs Resort in 1895. (Old Jail Museum.)

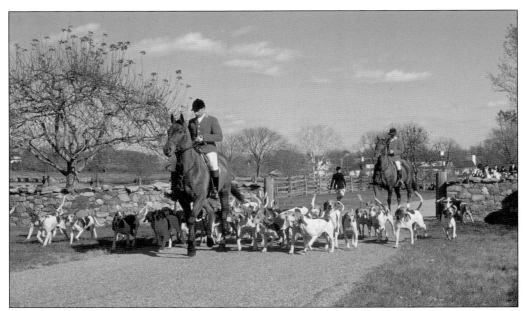

General Payne of the Black Horse Cavalry was the first president of the Warrenton Riding Club, predecessor of the Warrenton Hunt, in 1873. He bred his own foxhounds and was master of the hounds for the Warrenton Hunt, established in 1889. The first master of the hunt was James Maddux of Neptune Lodge. Though many members served during the wars in the 20th century, the hunt survived the Great Depression and still exists today. (Howard Allen Photos.)

The first master of the Old Dominion Hunt was Sterling Larrabee, son of the commissioner of Indian Affairs under Teddy Roosevelt. The Warrenton Hunt bordered the southern part of Old Dominion's territory; Gen. George Patton was a noted member of the club. The foxhunters brought prestige and wealth to Fauquier County; Madge Larrabee was a close friend of the Duchess of Windsor, Wallis Warfield Simpson. Pictured is Madge Larrabee at the Warrenton races. (Library of Congress.)

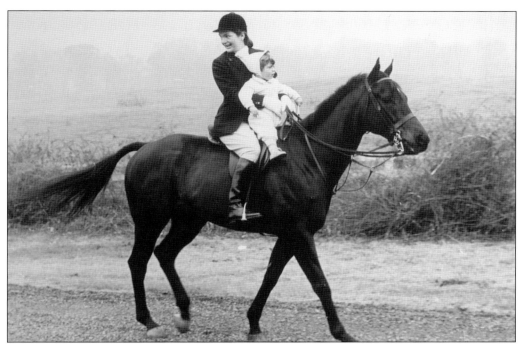

When John F. Kennedy was in office, the First Family fell in love with the beauty of nearby Middleburg, Virginia, where they rented an estate called Glen-Ora. Jackie O. was an accomplished equestrienne, frequently hunting with Piedmont and Orange County Hunts and competing at local horse shows. Horse country served as a respite from the political arena for the Kennedys. Horses were a family affair—her daughter, Caroline, was a budding rider; little Jon-Jon is shown in her lap. (Howard Allen Photos.)

The Warrenton Horse Show, founded in 1899, gave Warrenton a foothold in equestrian circles. Charlie W. Smith and Julian Keith obtained the charter, and the first show was held in the backyard of Neptune Lodge Stables, owned by hunt master James Maddux. Special trains were run from Washington, DC, for the event. "Everything that rolled on wheels was in evidence," regarding show transportation, according to the *Fauquier Democrat*. Shown are spectators at the 1916 show. (Library of Congress.)

Katherine Ingalls Sloan is pictured with her husband, George, on the nearest bleacher at the Warrenton Horse Show in 1935. She was a 1940 Virginia delegate to Democratic National Convention as well as president of the Fauquier County Tuberculosis Association in 1942. They lived on a farm named Whitehall, near Warrenton. (Library of Congress.)

The Warrenton Horse Show still occurs annually in Warrenton, with around 4,000 attendees. With great class and elegance, Mrs. A.K.B. Lyman, wife of Major Lyman, demonstrates typical period hunt and show attire. She is described as winning the course over eight fences "without wings" in 1935. The flaring of the jodhpurs, or riding pants, above the knee was to allow freedom and flexibility of the rider's leg while mounting and in the saddle. (Library of Congress.)

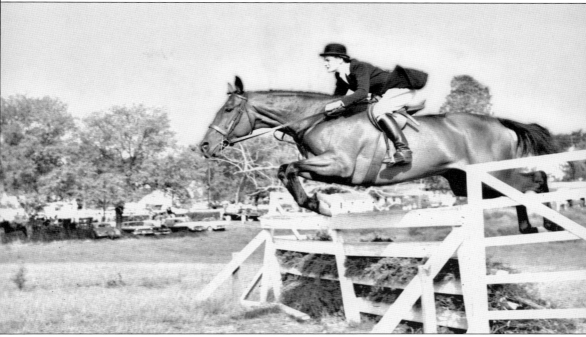

During modern horse shows, competitors are required to wear appropriate, approved safety gear, such as helmets. Mid-century riders at the Warrenton Horse Show did not have these rules, as shown here in this photograph of a hunter taking a fence with just a top hat. It is thought that women's riding attire became aligned with men's during the suffrage movement, steering it away from the long skirts worn in the classic sidesaddle discipline. (Howard Allen Photos.)

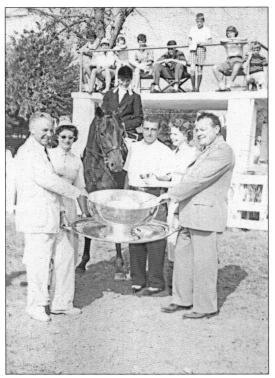

The Warrenton Horse Show is the oldest social corporation in Virginia. The oldest trophy in circulation was first presented in 1936. The show's vice president, Herman Ullman, initiated the fundraising for the trophy in honor of John Barton Payne—in Ullman's words, Payne was "one of the greatest humanitarians of his day . . . this award would perpetuate his memory in the county where he was borne and passed his youth." The trophy was an enormous silver bowl, shown in this photograph of the trophy's winner in 1957. (Howard Allen Photos.)

The horsemen and women of Fauquier County knew the competition was stacking up around them, as Maryland had already established a prestigious Hunt Cup Race in 1894 and Middleburg, Virginia, and Pennsylvania had done the same in the early 1900s. Fauquier County was eager for a cup of its own, and the county's wish would come true, as demonstrated by these eager spectators at the 1941 Gold Cup at Broadview Farm. (Library of Congress.)

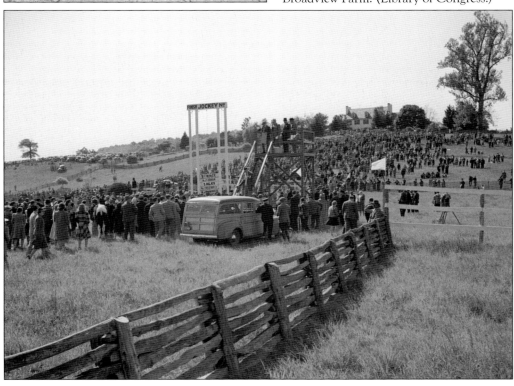

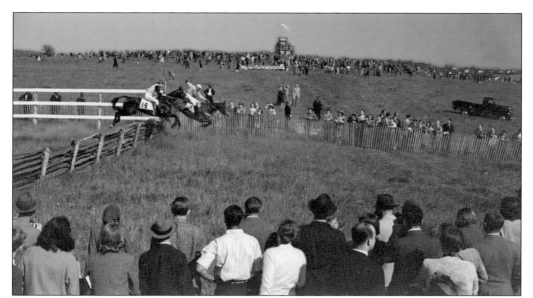

Steeplechases had been part of Virginia life since Colonial times. They were in part recreational races but also a means to show the best of an equestrian and mount's abilities. The Virginia Hunt Cup, now known as the Virginia Gold Cup, was organized in 1922 at the Fauquier Club, in hopes of attracting the best hunters in the area. Here, 1941 Gold Cup riders gallop past the spectators at the finish line in Great Meadows, the present-day location of the race. (Library of Congress.)

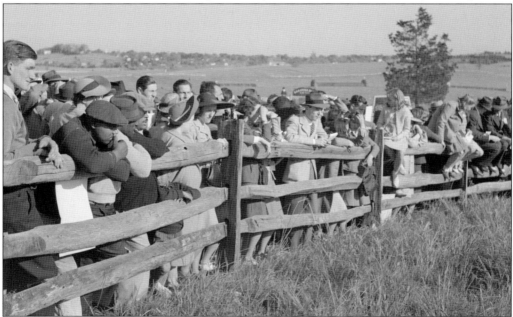

The Gold Cup grew to an event of massive importance, drawing huge crowds, intense competition, and occasional unruly behavior. The first Gold Cup was a single race, riders to be "gentlemen wearing racing colors or officers of the US Army in uniform." Nine horses competed that first race at Oakwood, an estate near Warrenton once owned by Lincoln's personal physician, Dr. Robert King Stone. Pictured are fields full of spectators. (Library of Congress.)

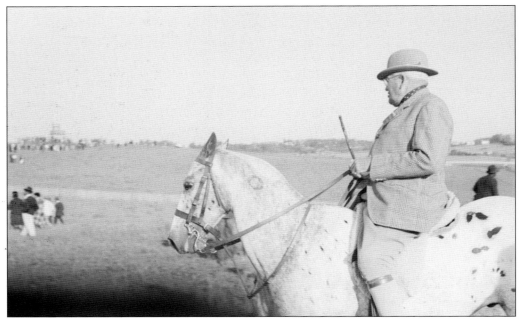

Pictured here, race judges were mounted as well and endured heavy pressure to make the right calls. The undisputed greatest horse in the history of the Virginia Gold and International Cup has been a bay gelding named Saluter. His race record includes six wins of the Virginia Gold Cup and two wins of the International Gold Cup. (Library of Congress.)

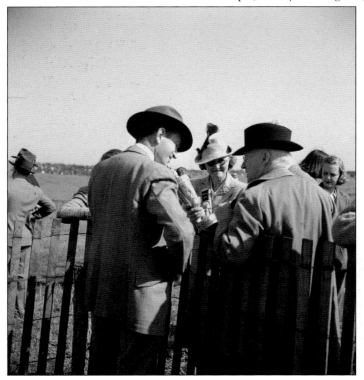

The famous prize, the Gold Cup, is shown in the center. The founders of the race designated $1,000 to go to purchasing the first Gold Cup prize. The original trophy dates to the 18th century and was owned by Catherine the Great of Russia. The horse owner who wins the Virginia Gold Cup five times is granted ownership of the trophy. In 2012, actor Robert Duvall presented the trophy to the winner at the 87th Gold Cup. (Library of Congress.)

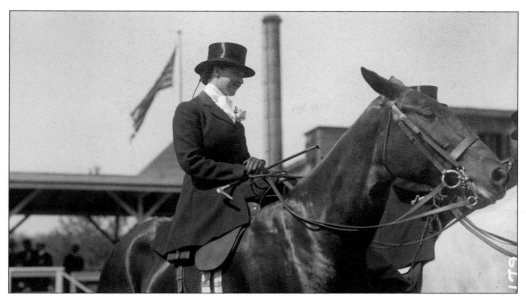

Irish Laddie, owned by Katherine Hitt of Middleburg, won the first Gold Cup steeplechase event. Laddie was trained and ridden by Middleburg horseman Arthur White. In 1925, Hitt surprised the race organizers by twice repeating her win with different horses to retire the first Gold Cup. In all the years since, the prestigious cup has been retired only six more times, most recently by the great Saluter in 1998. Katherine Hitt is shown here in the 1920s riding sidesaddle. (Library of Congress.)

The prestigious Gold Cup drew some celebrities as well, though social refinement and the unruliness of steeplechase racing seemed an unlikely combination. It still attracts many political leaders from Washington, DC, and actor Robert Duvall, a Fauquier County resident, has been spotted at the races. Pictured are, from left to right, Viola Winmill, Kenneth Jenkins, and Franklin D. Roosevelt Jr., son of President Roosevelt. (Library of Congress.)

The Gold Cup also brought the element of gambling to town. The first account of gambling on horses in Fauquier County took place at Great Meadow during the Gold Cup. Though illegal, local officials usually overlooked the large chalkboards scribbled with bets, the loud bookies, and the crowds around them. Parimutuel wagering for the Virginia Gold Cup was finally approved in 2013. Here, bookies take bets from eager gamblers. (Library of Congress.)

Along with any type of sporting event, the race was not without a fair amount of drunkenness—and it still has that aspect today. Due to the danger to horses and spectators alike, getting caught with a glass beer or wine bottle brings a $500 fine at the Gold Cup. Here, a spectator gets caught in the act. (Library of Congress.)

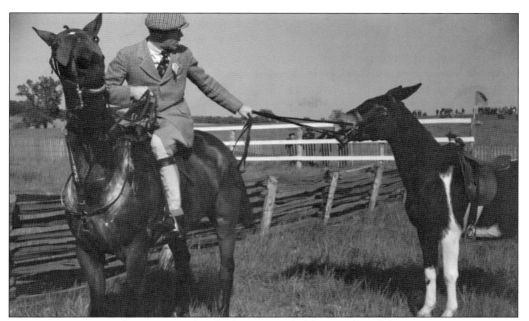

Not every equine was born to run; this donkey was probably part of a sideline entertainment act at the Gold Cup. Viola Winmill of Warrenton was a popular sight at the Gold Cup when she drove her carriage of six ponies around the grounds. Winmill also had a Sicilian donkey cart, now on display at Morven Park's Carriage Museum in nearby Leesburg. (Library of Congress.)

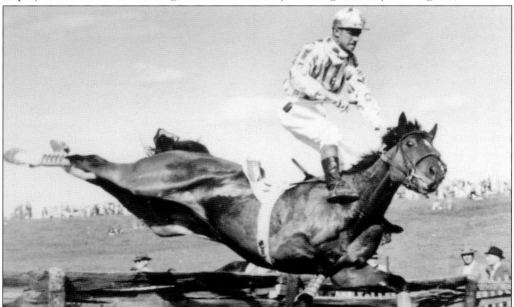

Steeplechasers carry an enormous amount of danger in their sport. Horse ambulances usually stand at the ready, as accidents are common at such a high-speed, intense competition. It is disturbing to imagine what happened upon landing to this horse and rider at the Virginia Gold Cup in 1960. In the early days, euthanasia of fatally wounded horses came with a bullet; thankfully, veterinary medicine has advanced significantly! (Howard Allen Studios.)

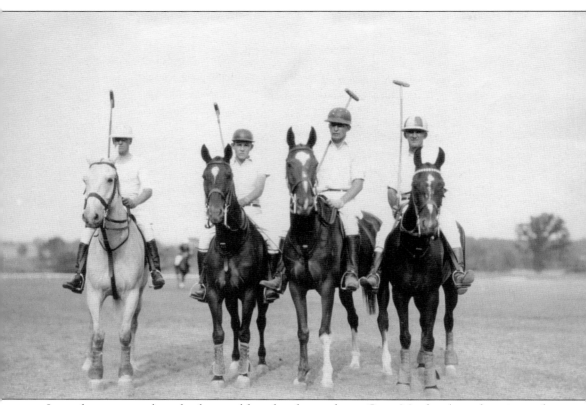

Lesser known were the polo players, although polo matches at Great Meadow (same location as the Gold Cup) are very popular today. Twilight polo is a major summer attraction for equestrians and tailgaters looking for an enjoyable evening at Great Meadows. The American Polo pony originates from Harry Payne Whitney's Thoroughbred stock crossed with quarter horses. Whitney was an eight-time winner of racing owner of the year and was related to John Hay "Jock" Whitney, also of racing fame and nearby Llangollen Estate in Middleburg. Harry is thought to have revolutionized polo into the high-speed sport of today, versus the more cautious British style of play. The Fauquier Polo Club was the first recorded polo club in Virginia. The Fauquier Polo team is pictured here; on the far right is John F. Walker, who was killed during a match in Harrisburg, Pennsylvania, in 1939. (John Gott Library.)

Five

THE 20TH CENTURY

The 20th century would bring a new era of technology and prosperity to Warrenton and Fauquier County—but it would not necessarily bring peace. Since the Civil War, Fauquier men and women have been exemplary in their efforts to defend their freedoms. During the World War I draft, Fauquier County was the first county to send its full quota, and Virginia was the first state in the nation to fill its quota.

Two world wars had a significant impact on the town, and the Warrenton Rifles, with the same courage and charisma as their Civil War ancestors, would band together and lay down their lives for their country once again. However, the strong patriotic streak that runs through the area would see the town through these challenges, as well as those of the Korean War and the Vietnam War. The historic district of Warrenton has been preserved and is now a hub of activity, with shops and restaurants. Throughout the town and its environs, new communities have sprung up over the last few decades, and the area holds enormous appeal for families. There is a strong arts and cultural aspect to the town as well. The quality of life here remains among the most appealing in the state of Virginia.

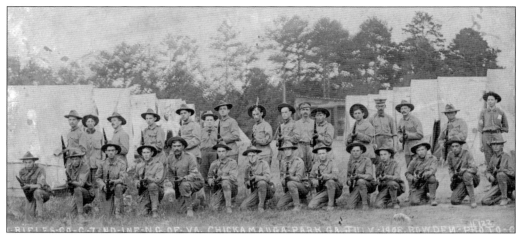

The Warrenton Rifles were sent to border patrol service in Mexico in 1916 and then to France when America declared war on Germany in 1917. They are pictured here in 1908. President Wilson sent posters to the men's families that read: "A man from this house is serving his country at the front in the US Army," to be hung in their windows. One of the posters is on display at the H.L. Pearson National Guard Armory in Warrenton. (Old Jail Museum.)

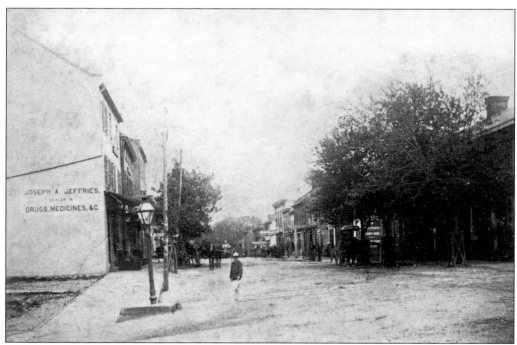

Joseph A. Jeffries was a pharmacist by trade but patriotically joined the Warrenton Rifles at the start of the Civil War. He carried his expertise to war, becoming manager of the Confederate medical supplies. He returned to Warrenton after the war and operated his pharmacy here at 15 Main Street. (Old Jail Museum.)

Vint Hill Farms Station, currently an inn, is about 10 miles northeast of Warrenton. It was sold to the US Army in 1942 for $127,000; the Army used it as a monitoring site for enemy communications during World War II. Pictured is a monitoring station set up inside a barn by the 2nd Signal Brigade; these technological concepts became the standard for field stations worldwide. During the Cold War, it served as an intelligence support facility. (Old Jail Museum.)

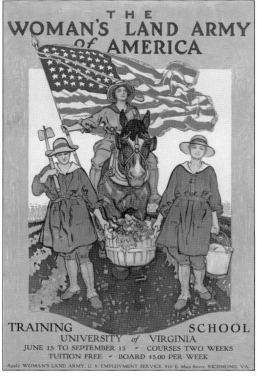

The ladies of the Loudoun-Fauquier Garden Clubs formed a committee, headed by Charlotte Noland of Loudoun County's historic Foxcroft School. It served to fill labor vacancies left by enlisted men. Over 200 women joined what would become the Women's Land Army of Virginia, performing arduous tasks such as harvesting and delivering crops from around the county. Pictured is a post from the Women's Land Army of America's training school at the University of Virginia in Richmond. (Library of Congress.)

Organized again in 1941 with 43 men during World War II, the Warrenton Rifles reconstituted to fight again. Drills took place in the Warrenton High School gym; as volunteers, they suffered funding issues. Members of the Warrenton Rifles raised their own money through fundraisers and donations to buy their uniforms. In just eight months, the Warrenton Rifles would be tested by their service when World War II broke out after the bombing of Pearl Harbor. The Warrenton Rifles are pictured here in town in 1917. (Old Jail Museum.)

Many landmarks around Fauquier County are named after Judge John Barton Payne, who is well known for his work as chairman of the American Red Cross. He was also a judge in Chicago, president of the US Shipping Board, secretary of the Department of Interior under President Wilson, and counsel to the Emergency Fleet Corporation during World War I. In 1921, Judge Payne pledged enough money to grant Warrenton's library a permanent home, which consequentially named the building after him. (Library of Congress.)

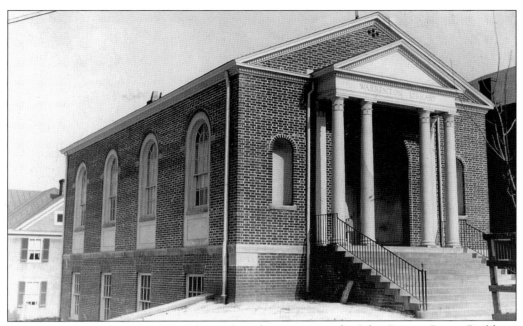

The Warrenton Library was once located in this structure, the John Barton Payne Building, until the library was moved across the street. This is the building granted to the town library by Judge Payne's generous donation. This building now holds library and community events. (Anderson Collection.)

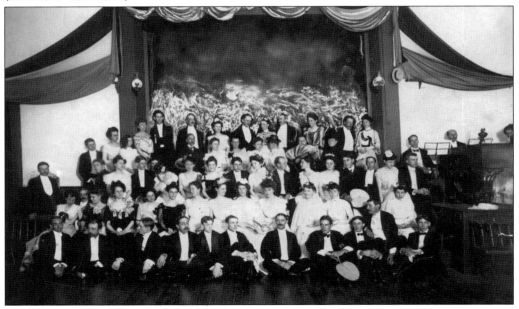

The Warrenton Cotillion was held in the John Barton Payne Building. The cotillion was designed to influence self-confidence and character through patterned social dancing. Cotillions have been documented in America since the late 18th century. Quadrilles, waltzes, and square dancing were all part of the cotillion ball. The ladies and gentlemen of the cotillion can be seen here in the 1890s in beautiful, formal period dress. (Old Jail Museum.)

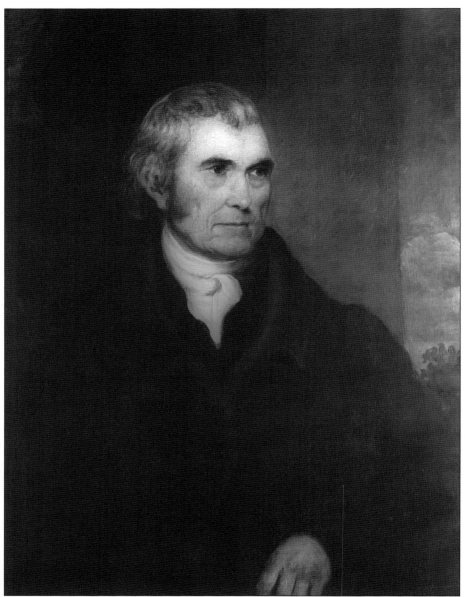

Erected in 1959, a statue honoring Chief Justice John Marshall stands in front of the Juvenile and Domestic Court building in Warrenton. From 1801 to 1835, he was the country's third and longest-serving chief justice. The Fauquier County native began his law practice in Warrenton. The large painting of him that hangs in the courthouse was taken down, concealed in a tin tube, and sent to Cincinnati during the Civil War, to keep it safe from plundering or fire. John Marshall was a leader in championing the third judicial branch of government, upholding it as supreme over the other branches. Marshall presided over the treason trial of Vice Pres. Aaron Burr, stating that no overt act had been committed, in following the words of the Constitution. A jury acquitted Burr, and President Jefferson felt great animosity toward Marshall. Marshall and Jefferson were both descendants of the Randolph family, who had roots in Fauquier County. (Library of Congress.)

John Marshall's father, Thomas, bought Oak Hill in Loudoun County in 1773, and he and his family lived there until 1783. The Chief Justice John Marshall's son John Marshall II inherited the property but found it too expensive to maintain, so it was sold to his brother Thomas Marshall II. Thomas was killed during the War Between the States, and Oak Hill left the family. Pictured is President Coolidge on the grand front portico of the mansion in October 1926. (Library of Congress.)

Wallis Warfield Simpson, an American socialite, found herself in a fairy tale when she married King Edward VIII, who abdicated the throne for his bride. Simpson, awaiting her final divorce decree from her first husband, lived at the Warren Green Hotel from 1926 to 1928. Perhaps a bit spoiled, Simpson describes the hotel as "a classic example of what my mother used to call inferior decorating." Pictured are Edward VIII and Wallis Simpson on holiday together in 1936. (Wikimedia.)

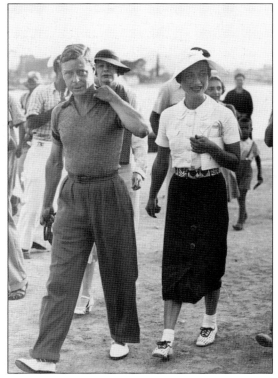

Civil rights leaders from Fauquier County met with Dr. Martin Luther King Jr. at Airlie, pictured here, to plan sit-in demonstrations for the promotion of desegregation. Harry Connelly Groome built Airlie in the early 1900s; it was destroyed a quarter century later. The Airlie Foundation was founded in 1959 on the property by Dr. Murdock Head and was a pioneering establishment for desegregation, justice, and civil rights. It has been called an "Island of Thought" by *LIFE* magazine. (Anderson Collection.)

Many older residents of Warrenton remember the old movie theater, pictured here. Managed by Pitts Theater, Inc., it was named Pitts Fauquier Theater and decorated in the Art Deco style of the 1930s. Keith Fletcher of Warrenton built the theater, as well as the bowling lanes—both businesses are no longer in existence. A *Free-Lance Star* article from 1932 describes the theater as being segregated. (Anderson Collection.)

The theater became the Downtown Theater in 1969 but closed in 1975 and now contains retail stores. An article in the *Free-Lance Star* advertises Pitts Theater as gladly accepting IOUs and urging patrons "not to be in anyway embarrassed" to do so during "the present unwarranted bank crisis," referring to the Great Depression. Benjamin Pitts, owner of Pitts Theater, Inc., owned 30 movie theaters in Virginia during this period. There was also a drive-in theater on Bear Wallows Road outside of town, near the Warrenton Training Center. The last Pitts Theater remains in Culpeper, Virginia, and is protected by the National Register of Historic Places. Pitts was also a member of the Virginia State Senate in the 1950s. Pictured is the theater in 1939, as John Wayne's *The Night Raiders* makes its premier in Warrenton. (Anderson Collection.)

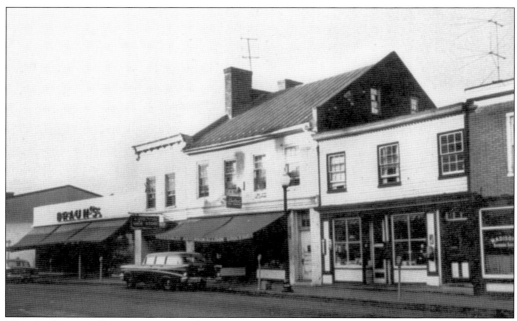

The Anderson-Allison Grocery and Warrenton Shoes, shown here mid-century, still stands on Main Street but is now home to restaurants. Arthur Robert Anderson and Luther Lee Allison owned it. Anderson's grandson Arthur Roy Anderson owns the historic Anderson Building across the street. (Anderson Collection.)

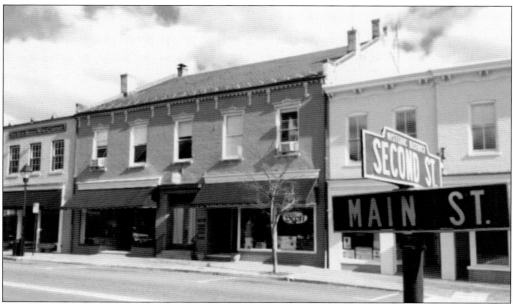

The Anderson Building is still owned by a fourth-generation member of the Anderson family. It was remodeled in the 1970s by Dr. Arthur Robert Anderson Jr. At that time, the basement had dirt floors and low ceilings but was converted into a dental office by Dr. Anderson. Records reflect that, during one sale of the property in the mid-1800s, the deed included two slaves that lived in the basement. (Anderson Collection.)

The county's second courthouse was built on this lot in 1764. Later, Hon. Lucien Keith built a home here on Culpeper Street. Lucien Keith was an attorney and a Virginia state senator, elected in 1918. The home is pictured here in the 1980s. (Bob Lawrence Collection.)

Today's Lee Highway, one of the main routes in and out of Warrenton, looks nothing like this old dirt road. "Lee" refers to the Virginia portion of the highway, overall, it is US Route 29—a north-south highway that runs for 1,039 miles starting at Baltimore, Maryland, and ending in Pensacola, Florida. Named for Gen. Robert E. Lee, it was an important automobile route to Washington, DC. This man was selling apple cider by the side of Lee Highway in 1935. (Photograph by Arthur Rothstein.)

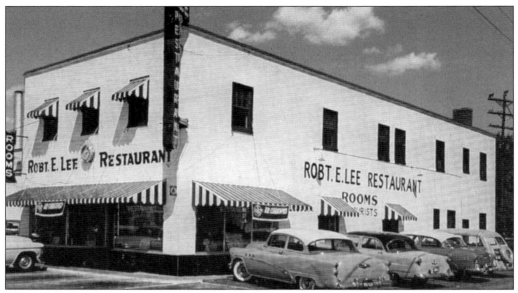

The Robert E. Lee Restaurant, opened in 1938 on Lee Highway, is now a hardware store. A 1940s postcard reveals the writer's meal there was "not so good." An advertisement seeking to hire servers says, "We pay more than you expect." The building is now home to J and D Handyman Services, across the street from the Carousel Ice Cream kiosk. (Anderson Collection.)

Located outside Warrenton, the 2,900 acres for North Wales was granted by Lady Catherine of Culpeper—mother of the 6th Lord of Fairfax, wife to the 5th Lord of Fairfax, and proprietor of the Northern Neck—to Col. Rice Hooe Jr. and Capt. John Hooe. John Hooe willed it to his daughters, and one of them, Anne, married William Allison, who built the initial two-story structure. In the 1900s, Edward M. Weld, leader in the New York Cotton Exchange from 1915 to 1922, owned the property where he stashed $50,000 of liquor in a hidden room during Prohibition. (Library of Congress.)

North Wales is a pristinely preserved example of several different periods of architecture over the last 200 years. An angry contractor who was unable to buy the property for development in the 1960s supposedly burned a gristmill and swimming area. Walter Chrysler once owned the plantation and contributed several items of interest, such as an orchid nursery. He also used North Wales as a stud farm for his Thoroughbred breeding operation. (Library of Congress.)

Walter Chrysler, the famed founder of Chrysler Motors, settled in Warrenton during his later years. In 1934, he purchased Fauquier Springs in an effort to renovate the historic resort; it was sold in 1953 as a country club and remains so today. Chrysler was *Time* magazine's Person of the Year in 1928. (Library of Congress.)

Carter Hall at 31 Winchester Street, pictured here in the 1980s, was rebuilt after the Great Fire of 1909. Today, it houses a law firm established in 1978—one of the largest and oldest in the county. Robert Lawrence, a firm member, has family roots that run within Carter Hall. The sophisticated, enormous brick home stands prominently over Winchester Street. (Bob Lawrence Collection.)

Edward Brooke was the first African American elected to the Senate and would remain the only one in the 20th century until 1993 and was the only African American senator to serve multiple terms. Brooke is a lawyer and a resident of Warrenton, Virginia. (Library of Congress.)

Six

MURDERERS AND GHOSTS

With a history steeped in revolution, war, segregation, and high profiles, Warrenton had no chance to escape crime and the supernatural. There are many ghost stories to tell about the town; there is even an annual ghost tour given by the Fauquier Historical Society. The Old Jail, which has incarcerated everyone from potato thieves to cold-blooded murderers, has hosted many eyewitnesses of the unexplainable. Several of the museum docents can tell stories of female apparitions appearing in the grand mirror of the main entrance, and one even found the footprint of a child in fresh paint while doing late-night maintenance—alone. The accounts have been documented in a delightful book of ghost stories, written by the museum director and available at the Old Jail. Susan Cummings, heiress of an arms dealer, shot her lover four times in the chest at her estate in Warrenton and walked free. Several lynchings were documented in Warrenton after the Civil War, credited to the Klu Klux Klan presence that lurked in town after dark. An African American man named Arthur Jordan was captured in 1880 for miscegenation when he eloped with a white woman. He was incarcerated in the Old Jail but was dragged out before trial by men in white hoods and hanged during the night from a locust tree in the cemetery. From crimes of passion to ghosts of lost soldiers and even a skeleton hidden in a wall, Warrenton has a macabre side that casts an eerie but compelling shadow on the town, despite its cheery and bustling nature by day. The knowledgeable staff at the Fauquier Historical Society gives spooky details of paranormal accounts to groups standing outside each corresponding haunted building in Warrenton every year around the end of October.

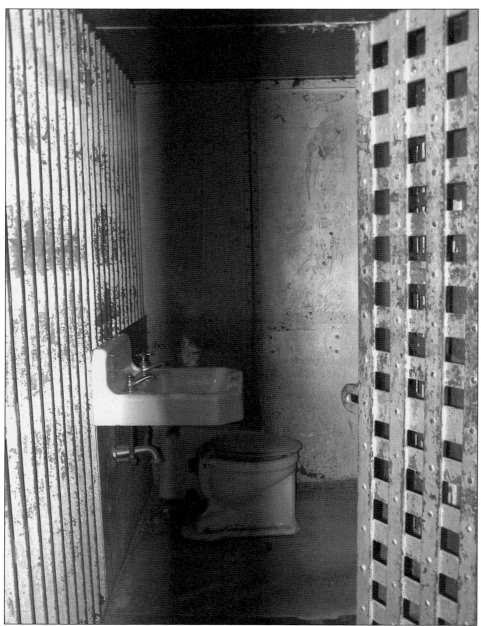

A ghost named Mr. McG haunts the Old Jail Museum in Warrenton. Mr. McG was arrested in 1920 for attempting suicide and arson after he burned down his own farm in protest against relatives plotting to take his property. Due to poor health, the jailor decided he should be moved to a private residence while he awaited sentencing, but Mr. McG died in his cell before he could be relocated. Later, an incarcerated woman was placed in the same cell. At trial, the judge asked if she had received visitors, and the outraged woman described an old man who came into her cell each night and attempted to steal her bedding. Mr. McG's attorney Robert A. McIntyre was present during her claim and verified that her description perfectly matched Mr. McG. Pictured is one of the eerie cells; the walls are covered in graffiti from the inmates over the years. (Kate Brenner.)

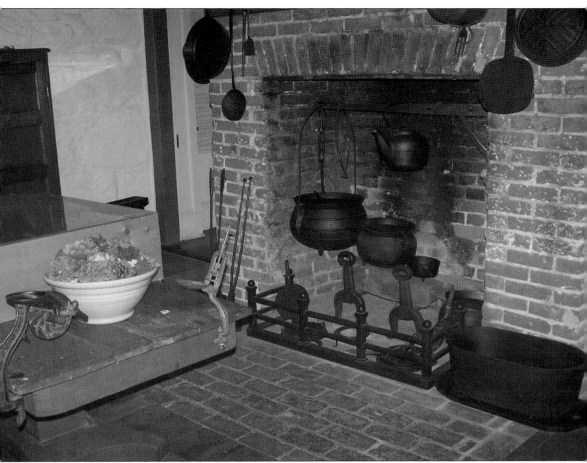

Since then, mysterious footsteps have been heard many times by a former president of the historical society, working after hours at the Old Jail in the kitchen. One time, while working upstairs, he noted a small footprint in fresh paint, though no one was present. In the 1900s, a docent was on duty by herself Christmas Day, waiting for a special group visiting from Europe. She heard the latch clicking on the small door in the kitchen that led to the bedroom above. Upon investigation, the latch stopped but the chandelier began to swing wildly around. Years later, a committee met in the jail and witnessed a woman in white walk out of the kitchen, through an Elk Run display, and disappear through a wall. Others have witnessed this same woman in recent times. A student volunteer felt someone stroking her hair and arm while cleaning a storage room near the maximum-security cell. The jailer's kitchen at the Old Jail is pictured here. (Kate Brenner.)

The Haunted Kitchen on Culpeper Street was an old, detached structure. Since they were fire hazards, kitchens were removed from the main home. It is reported in *Virginia Ghosts* by Lee Moffett that around 1930 "the negro population always said the old building was haunted" and very few were willing to work there. The owner employed a young servant, Eva Gibson, because she "often heard queer noises but was never frightened by them and was well acquainted with the spirits and was used to them." Eva claimed she saw an elderly black woman carrying a small baby several times in the kitchen. Later, the homeowner hired a laborer, Charles Marshall, to perform repairs on the kitchen. Marshall knew the woman who used to work there, describing her just as Eva did, and he recalled the woman had adopted a small, orphaned baby when one of her family members died. (Bob Lawrence Collection.)

Col. William Chapman was serving as an officer in Warrenton during the Civil War when he learned about Mosby's Rangers. Chapman joined the rangers as second in command on their raids and continued to serve with Mosby through the fall of 1863 to 1864. On one account of discovering Sheridan's troops had burned the countryside near Berryville, Chapman is remembered as ordering, "Wipe them from the face of the earth! No quarter! No quarter! Take no prisoners!" He served Mosby until the close of the war in April 1865. After the war, he worked for the Internal Revenue Service in Greensboro, North Carolina, where he died and was buried. His ghost returned to his beloved c. 1790 Edgehill home outside Warrenton, where he and his wife, Josephine Jeffries, were married. His ghost has been seen wandering through the library. The ghost is responsible for opening locked doors and making loud noises late at night. (John Gott Library.)

Paradise, located at 158 Winchester Street, was originally the home of Martin Pickett, built in 1758. Pickett was sheriff, tax commissioner, and coroner and served in the Revolutionary War; he also was the great-grandfather to Gen. George Pickett, who led the famous Pickett's Charge at Gettysburg. For his service in the war, Col. Martin Pickett was granted the property of Oakwood, where the first Gold Cup was later run. Colonel Pickett handed it over as dowry for his daughter's marriage. It was later named Bleak Hill during the Civil War due to the destruction of the once beautiful view of "paradise." The Union armies burned 250 acres of fencing, a significant loss to the property. The legend of a badly wounded soldier's ghost in the attic pleading for someone to contact his family lurks in the estate's history. There is also a faded growing chart that marks a child's growth in the attic. Here is Paradise, photographed in 1978. (Old Jail Museum.)

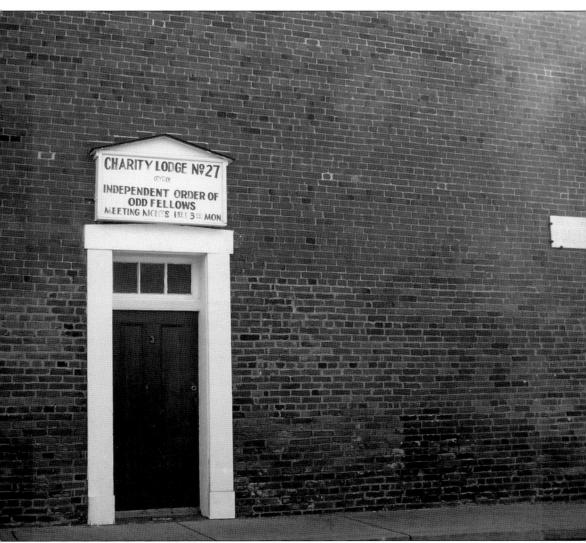

In 2001, between the brick walls of the Warrenton Odd Fellows, an unsuspecting electrician, Paul Wallace, found a skeleton in a white shroud surrounded by candles. He recalls, "It was like a Dracula movie . . . The top of the skull was covered, but you could see the rib cage and the sinew." The Odd Fellows date back to the 1700s as a charitable organization that helped needy families properly bury their dead when they could not afford it. It is said that initiation ceremonies involved blindfolding the candidate and then revealing to them a shrouded skeleton to make them understand the importance of mortality. The skeletons were usually acquired from scientific catalogs or donated through wills. All that is known about the skeleton is she was a 5 foot, 1 inch Caucasian, and her jaw, arms, and feet were missing. (Kate Brenner.)

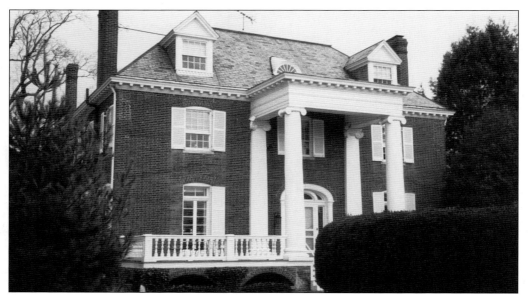

Loretta was built on part of the original Richard Henry Lee parcel in 1759, known then as Edmonium when Capt. Elias Edmond, who was also the contractor for the Old Jail construction, owned it. A woman in gray was witnessed on the grounds, carrying a candle. Legend claims that occasionally heavy furniture is moved to block a bedroom door, laughter from a nonexistent party haunts the main floor, and an Indian burial ground is located underneath the mansion. (VA Dept. of Historic Resources.)

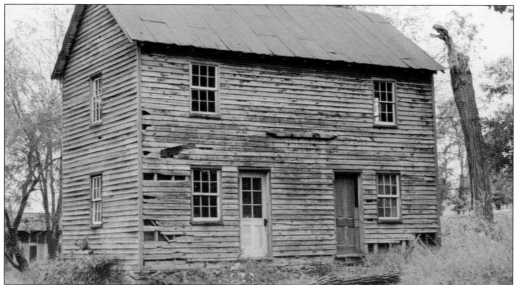

Leeton Forest, an 18th-century home in Warrenton, had tenants who claimed a bedroom door upstairs would not stay closed, despite chains and padlocks. They heard a rocking chair squeak every morning around 7:00, as well as footsteps, pouring water, and the sounds of hand washing despite the room's vacancy. Later, the home burned to the ground, but the tenant found a mysterious box; its contents were obviously used to build a much grander home, although no one knew exactly what the box held. With the new home, the paranormal accounts ceased. (John Gott Library.)

Susan Cummings, daughter of billionaire arms dealer Samuel Cummings, lived here at Ashland when she was accused of murdering her lover, Argentine polo player Roberto Villegas, in 1997. According to police reports, Roberto Villegas was found with a knife crossing his arm, and the coroner's report suggested Villegas was shot while he was sitting at the kitchen table. Susan Cummings presented some minor cuts, which the police suspected were self-inflicted. Blair Howard, Cummings's attorney, also represented Lorena Bobbitt during her famous case. Cummings had written letters to the sheriff's department about Villegas's aggression and scheduled a meeting with them one day after she shot him. Police also found open boxes of ammo and an empty holster upstairs, though she claimed to have shot him in self-defense with a loaded gun she kept in her kitchen. She served 51 days in jail and paid $2,500 in fines even though the jury found her guilty. In 2004, Lisa Pulitzer wrote a book on the case called *A Woman Scorned*. Shown is Ashland in 1930. (Library of Congress.)

Discover Thousands of Local History Books Featuring Millions of Vintage Images

Arcadia Publishing, the leading local history publisher in the United States, is committed to making history accessible and meaningful through publishing books that celebrate and preserve the heritage of America's people and places.

Find more books like this at
www.arcadiapublishing.com

Search for your hometown history, your old stomping grounds, and even your favorite sports team.

Consistent with our mission to preserve history on a local level, this book was printed in South Carolina on American-made paper and manufactured entirely in the United States. Products carrying the accredited Forest Stewardship Council (FSC) label are printed on 100 percent FSC-certified paper.

MADE IN THE
 USA